PHOTOMONTAGE

A Step-by-Step Guide to Building Pictures

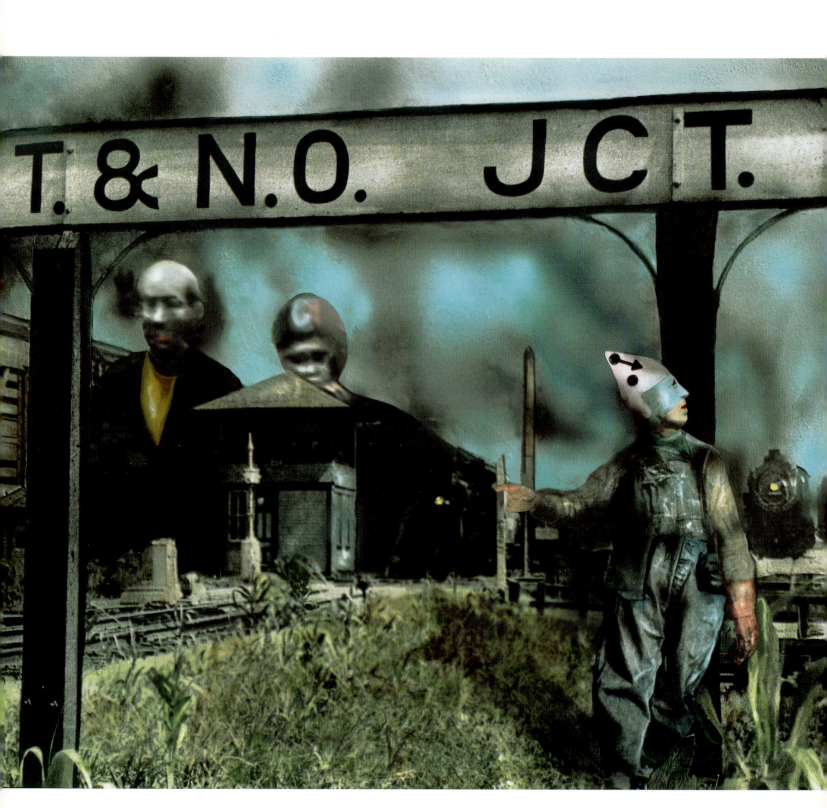

PHOTOMONTAGE

A Step-by-Step Guide to Building Pictures

Written and Illustrated by STEPHEN GOLDING

Rockport Publishers, Inc.
Rockport, Massachusetts
Distributed by North Light Books,
Cincinnati, Ohio

Dedication

This book is dedicated to Mark Golding for getting me on the photographic track and Janice Reilly for helping to keep me on it.

Acknowledgments

I would very much like to thank:

My family for a lifetime of support and encouragement

Arthur Furst for getting me started in this project

Winnie Danenbarger, Lynne Havighurst, and all the other patient-helpful people at Rockport Publishers

Special thanks to the big man with the little name, Don Fluckinger—in whose hand the pen is mightier than a poorly placed comma

John Jacob for writing the Foreword

The artists who generously permitted their work to be used in this book

Electronic Imaging Center, Boston, MA— a service bureau where artists are welcome

The Camera Company, Norwood, MA— for the use of their excellent facilities

Dave Gaudet; the Photoshop maven and Creative PrePress, Woburn, MA

MetaTools Inc.

Adobe Systems Inc.

© Copyright 1997 by Rockport Publishers, Inc.

First published in the United States of America by:
Rockport Publishers, Inc.
146 Granite Street
Rockport, Massachusetts 01966-1299
Telephone: (508) 546-9590
Fax: (508) 546-7141

Distributed to the book trade and art trade in the United States by:
North Light Books, an imprint of
F & W Publications
1507 Dana Avenue
Cincinnati, Ohio 45207
Telephone: (800) 289-0963

Other Distribution by:
Rockport Publishers, Inc.
Rockport, Massachusetts 01966-1299

ISBN 1-56496-289-x

10 9 8 7 6 5 4 3 2 1

Designer: Dutton & Sherman, New Haven, Connecticut, USA

Front cover illustration Stephen Golding
Frontispiece *Road to Necropolis*, Stephen Golding

Printed in Hong Kong by Regent Publishing Services Limited

Contents

Foreword

In photography's earliest years, as new optical and printing technologies were created and explored by amateurs working in different fields, photographic images were frequently combined with other media to enhance their effect or message. By the 1840s, daguerreotypists had already begun to hand-tint portraits, adding naturalistic water colors to their monographic mirrors. By the late 1800s, British photographers such as Oscar G. Rejlander and H. P. Robinson, along with scientist Francis Galton, began experimenting not only with different photographic processes (wet-plate versus dry-plate, for example), but also with such techniques as combined or composite photography, which brings together elements from many negatives to create a single photograph.

Mixing the real with the ideal, these early photographers constructed their images to form visual narratives, in the case of Rejlander and Robinson metaphorical, and in the case of Galton, scientific. In the early 1900s an American photographer, Lewis Hine, extended this practice in a new, distinctly political direction by creating montages that combined words of condemnation with his photographs of working children to incite action against inhumane labor practices. By the time of Hine's successful campaign in the first decade of this century, however, lines were being drawn within the artistic community that separated creative from social photography. As photography that served social needs, such as Hine's, was devalued by the likes of American artist Alfred Steiglitz and writer Charles Caffin, photomontage, with its direct links to political and economic issues, acquired the stigma of an impure practice.

Today, however, as this book shows, montage has acquired a new and growing status. Slowly, museums and their audiences have come to recognize and value the works of Lewis Hine, the anti-fascist photomontages of German artist John Heartfield in the 1930s and '40s, as well as the montagist experiments of the Surrealists. We also value the images made by their successors, such as American artists Jerry Uelsmann and Barbara Kruger, whose work with photomontage is deeply relevant to the disorder of contemporary life. In fact, as our world has been transformed by the flux of eco-nomic and political pressures, the technique of montage has become increasingly appropriate to the artistic goal of creating meaningful narratives. In Stephen Golding's photomontages, for example, the real is mixed with the unreal and the terrifying to create images that jar the senses, that under-

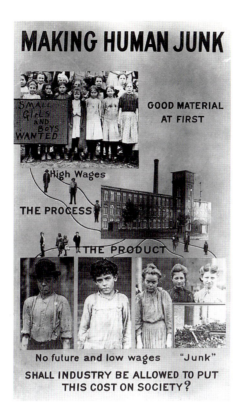

MAKING HUMAN JUNK

GOOD MATERIAL AT FIRST

High Wages

THE PROCESS

THE PRODUCT

No future and low wages "Junk"

SHALL INDUSTRY BE ALLOWED TO PUT THIS COST ON SOCIETY?

Lewis Hine's *Making Human Junk*: This montage led the way to the enactment of U.S. child labor laws.

mine conventional wisdom and arouse the viewer from complacency.

Just as we are surrounded by the pastiche of conflicting styles and images in contemporary art, however, we are also inundated, in and outside of our homes, by the advertising industry's images of an ideal life of consumption. Montage is the predominant technique practiced by artists and graphic designers working in the commercial media. Curiously, in advertising the seamless blending of images and text is used to sell products, while in the fine arts the same technique is often used to critique consumer culture. But as montaged images by artists and advertisers compete for the same public spaces, such as billboards, magazine pages, and gallery walls, it is the power of photomontage as a technique of rhetorical persuasion, more than any individual message or product, that becomes increasingly a part of our perceptual and intellectual language. From the early photomontages of Hine to the postmodern architecture of I. M. Pei, from the constructed images of Robert Rauschenberg to the "cut-up" texts of William Burroughs, montage has become the critical method by which we look at and interpret the contemporary world.

Montage is one of the most important directions in which photography will continue to develop. This is due, in part, to the relationship of photomontage to art and advertising. No less important to that development, however, is the ongoing technological transformation of photography into digital imaging, which has simplified and made accessible the montage process. With the growing availability of inexpensive scanners and software, digital imaging and image processing have begun to supplant the primacy of the camera and the darkroom. It no longer requires an artist to remove a blemish or unwanted relative from a photograph, or to cut an image of oneself in the backyard and paste it into a picture of some distant city. Most importantly, though, photomontage is important for the ability that it provides us to depict the extraordinary complexity of contemporary life. Photomontage will continue to develop in exciting new directions as both humans and the technologies they build to communicate their experiences continue to evolve. By giving readers the tools for both manual and digital photomontage, this book will contribute greatly to that process.

John P. Jacob
Director, The Photographic Resource Center at Boston University

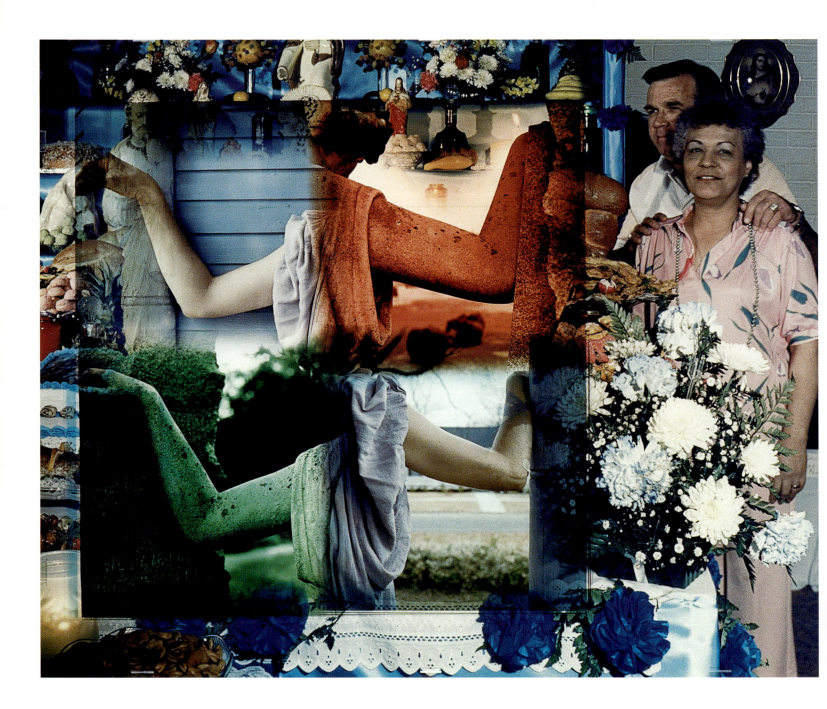

Bart Parker
Project *We Have Loved: Stone Daughters, Departed Sons*
(one of a series)
Rendering size 16" x 20" (41 cm x 51 cm)
This photograph illustrates how photomontage can be
used to communicate complex issues that would be diffi-
cult to show with a singular image.

Introduction

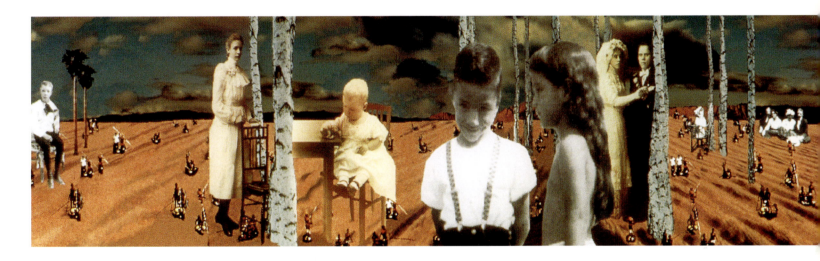

The premise

The intention behind writing this book was to provide artists with a resource for increasing their ability to express themselves. Readers will find photomontage a medium of limitless possibilities, enabling them to communicate their ideas by combining multiple pictures into a single image.

The goal is to encourage artists to experiment by combining digital and mechanical methods in a layered process, resulting in images lacking the "thumbprint" of a singular technique. Readers are encouraged to view the information in this text not as one long process, but as a suite of processes. With that in mind, artists should choose the methods that suit their particular needs.

Martina Lopez
Project *Courting with Time*
Rendering size 22" x 90" (56 cm x 228 cm)
The seamless look of this image exemplifies the contribution digital imaging has made to the medium of photomontage.

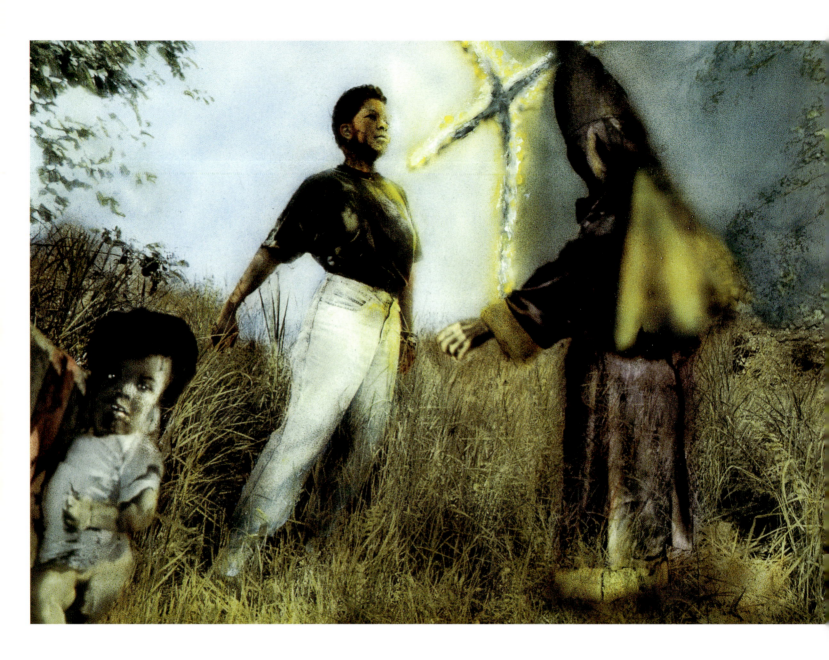

Stephen Golding
Project *A View From the Back of the Bus* (one of a series)
Rendering size 20" x 24" (51 cm x 61 cm)
Borrowing on photography's reputation as a truthful medium, this photomontage derives its impact by impersonating a conventional photograph.

Why photomontage?

Photomontage is arguably the most empowering of all artistic media. It thrives on diversity, allowing artists to express themselves with great impact and specificity. There is no rule book or traditional way of working; it's a medium that rolls with the ever-changing technology—offering artists unlimited personal expression.

Traditionally used to document our shared history, as well as the lives of individual families, the power of photography lies in its ability to reflect the truth. When artists use photography—even figuratively, as in photomontage—they rely on its reputation as the truthful medium. This advantage, albeit subliminal, empowers photomontage to "lie with a straight face."

Mechanical and digital methods

Often artists become entrenched in a particular way of working, and their art suffers as a result. They associate themselves strictly with either traditional methods or computer graphics. Photomontage can be a meeting of the ways, offering traditional artists a way to blend the new with the familiar, and digital artists the past with the future.

Work produced mechanically—even with the most skillful hands—often looks cut-and-pasted. Working this way also offers little or no control over various photographic issues, such as depth of field or lighting.

However, the question in the digital age is not whether mechanical methods are necessary, but if they are desirable. For some artists it boils down to two issues: some find the digital studio sterile, not conducive to the creative process; others simply prefer the aesthetics of mechanically produced art.

To understand the creative significance of digital imaging, think of it in these terms. Imagine you had always taken pictures using a simple box camera—and then switched to a 35mm single-lens reflex camera. Suddenly you have control over variables such as film, lenses, depth of field, and shutter speeds. With a computer, the artist can now address these traditionally photographic concerns without a camera. This new method of working exists under the banner of digital imaging. Greater control, however, means greater complexity. No longer working with simple tools, the artist must accept the challenges this technology offers.

The primary advantage of working in photomontage is flexibility—it enables artists to mix media and techniques to convey their ideas. Every process, whether its painting, photography, airbrushing, or something else, brings to the artistic dialog its own voice and form of expression. Remember, the value of artwork derives not from the complexity of the process, but from the substance of the idea. Ultimately, as with any task, success begins with a good plan and is achieved with the use of tools, not because of them.

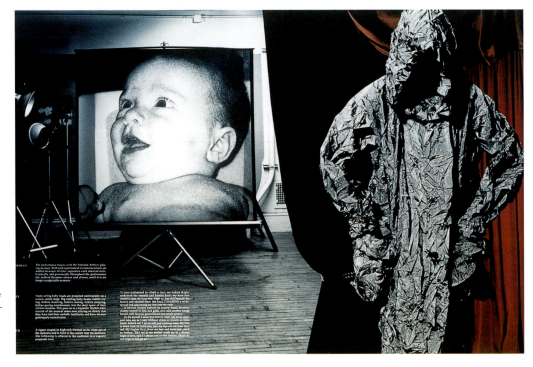

William Larson
Project *Theater du Monde*
(one of a series)
Rendering size 25" x 38"
(64 cm x 97 cm)
Mechanically made photomontages like
this one—looking obviously constructed—
encourage the viewer to ponder the
artist's motivation for combining these
specific pictures.

The bottom line

The question remains, what does this all mean to an artist working in photomontage? Certainly all of the above must be taken into consideration. Mechanical techniques give the artist a connection to the materials unmatched in the digital world. On the other hand, the computer has become an extension of both the camera and the paintbrush. Its potential as a creative force may dwarf all that came before it. However, in matters of aesthetics bigger is not necessarily better.

Having access to more tools can simply mean greater difficulty in communicating your ideas. Working in photomontage, mechani-cally or digitally, requires an understanding of more than just tools and methods. The artist must first understand how to build pictures from the bottom up—and how people relate to those pictures.

Note: The Adobe Photoshop procedures outlined in this book cover Version 4.0. In text, Macintosh key commands are referenced first, with their PC equivalents following in brackets. All scans are made within Photoshop, using a scanner and compatible plug-in. All dye-sublimation prints shown are made on coated papers, as uncoated prints may be adversely affected by some sprays. A more lasting print can be made by photo-mechanically copying the picture as shown on p. 29. The TIFF format will work for saving most files; the author recommends saving to EPS format.

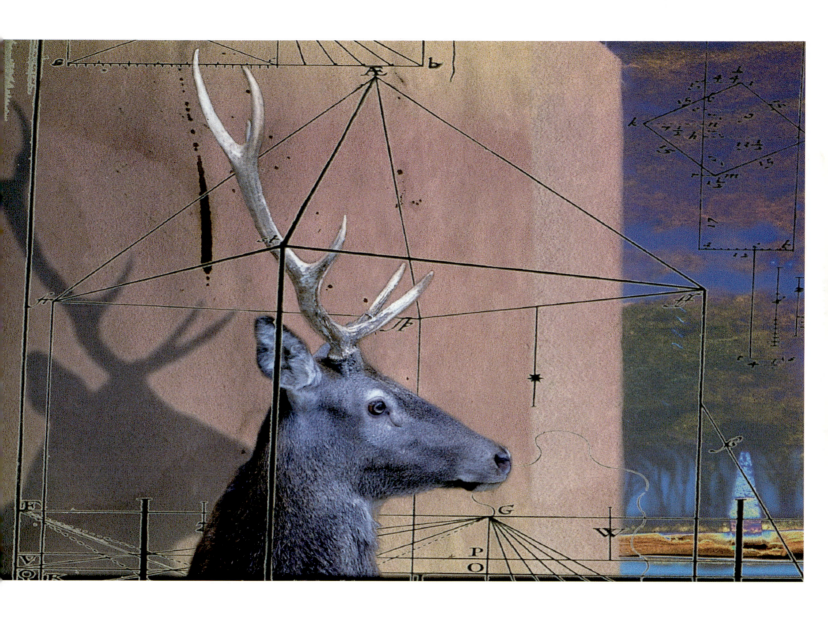

Olivia Parker
Project *Game Edge*
Rendering size 22" x 24" (56 cm x 61 cm)
Digital techniques enabled this bizarre assemblage to
congeal into a singular powerful image.

Building a Picture

Learning to work in photomontage requires the artist to think anew about a familiar subject. We have all looked at pictures for many years as the sum of their parts; we read a picture by assimilating all the separate bits of information into a singular message. To begin thinking about pho-tomontage, first consider that *all* photographs, regardless of how they're made, are composed of individual elements. The following demonstration assumes that a more literal, rather than abstract, picture is desired. However, the basics would apply in either case.

The images above are two of the source photographs for
A Day at Rockaway Beach. The final montage appears on page 21.

Setting the stage

1 Shakespeare said, "All the world's a stage." In the same way, every picture can be thought of as a stage. In traditional photography the stage is recorded as it's found, with the setting, players, and lighting being determined by nature. In photomontage you build the picture as though you're directing a play. Start with a stage, hereafter called a base picture. The imaginary play being staged here is called *A Day at Rockaway Beach*.

Adding a backdrop and player

2 The base picture can be composed of one or more pictures. A beach background has been placed into the base picture, establishing a context and horizon line. Now the foreground and background are clearly established.

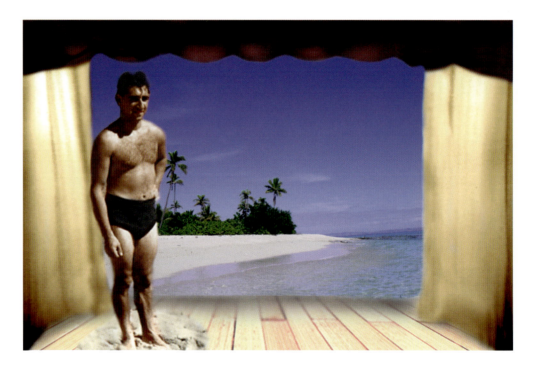

3 Remember, a stage is three-dimensional. When an object or person taken from another picture—henceforth called a picture element—is placed into the base picture, its size determines whether we see it as existing in the foreground, middle ground, or background. A medium-size picture element (first player) placed on the stage indicates by its size that it's in the middle ground.

Arranging the players

4 If a picture element (second player) is very large and covers the established foreground, it is understood to be very close. Sometimes having a picture element go out of the frame (off the stage) is an effective way to emphasize a visual point.

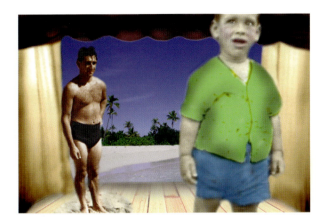

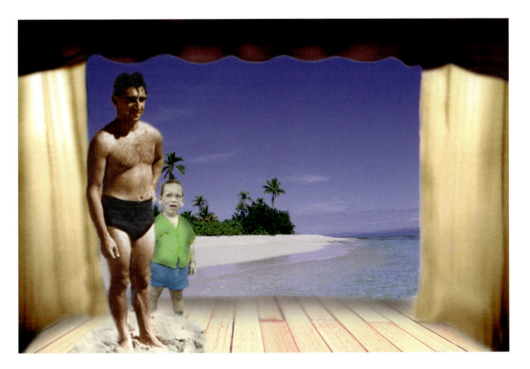

5 Moving one middle ground element behind another establishes which is closer. The ways you can combine the picture elements are almost unlimited. Each arrangement will have a different meaning; forethought is essential if a precise message is to be conveyed.

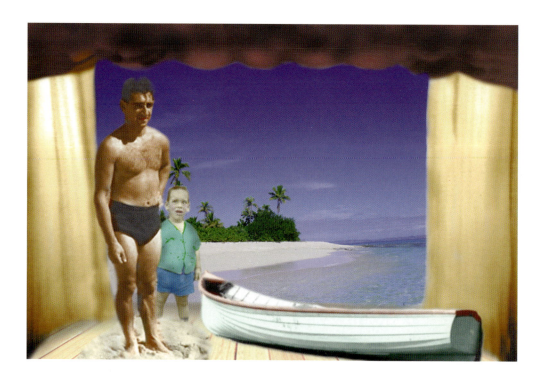

Establishing proportion

6 Proportion is also an important part of composing, or staging, our scenario. The boat seems to fit the setting, but look closely; it is actually too small to be a logical component in this picture. Attention to details is an important part of building a photomontage.

7 When the boat is scaled and placed logically in the base picture, it is seen as part of the background. Its small size and placement on the shoreline indicate its distance from the foreground.

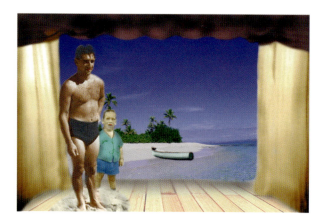

Directing the action

8 A fourth picture element (third player) changes the dynamic of the picture (scene). Although it's not covered by anything in the foreground, the size of the new picture element reflects its placement in the base picture—it's logically perceived as being a little behind the other two picture elements.

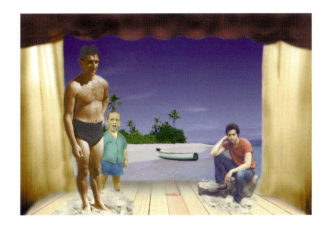

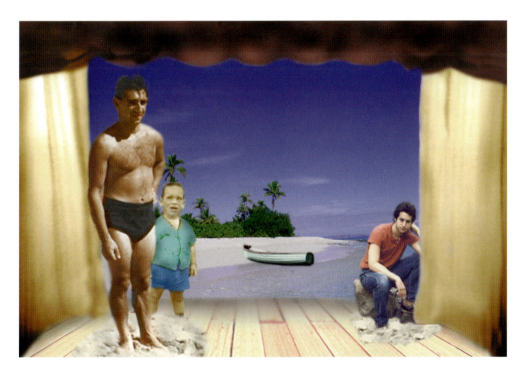

9 Notice how reversing the picture element on the right—placing it off-stage—changes the message of the picture. One simple change heightened the sense of tension within the composition, because each picture element derives its meaning from its relationship to the ones around it.

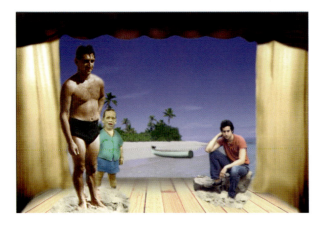

Focusing attention with light and shadow

10 The picture is again restored to a more contemplative scene. The background is now blurred; leaving the background in focus would make for an artificial, flat-looking image. In the real world, depth of field would handle this issue naturally. An artist creating a photomontage mechanically must plan this step carefully—working digitally has a distinct advantage in this area.

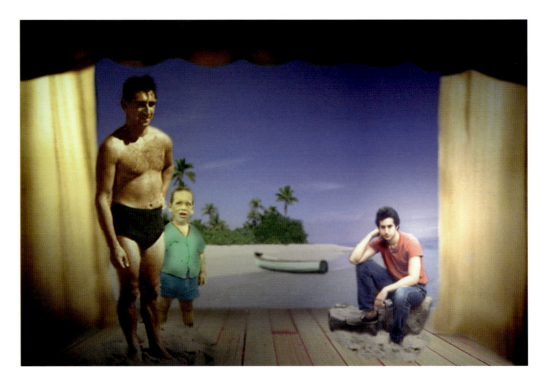

11 In the theater, lighting plays an important role by enhancing the desired atmosphere and directing the audience's eyes to the action. It does the same thing in a photomontage, as well as helping to integrate all the elements.

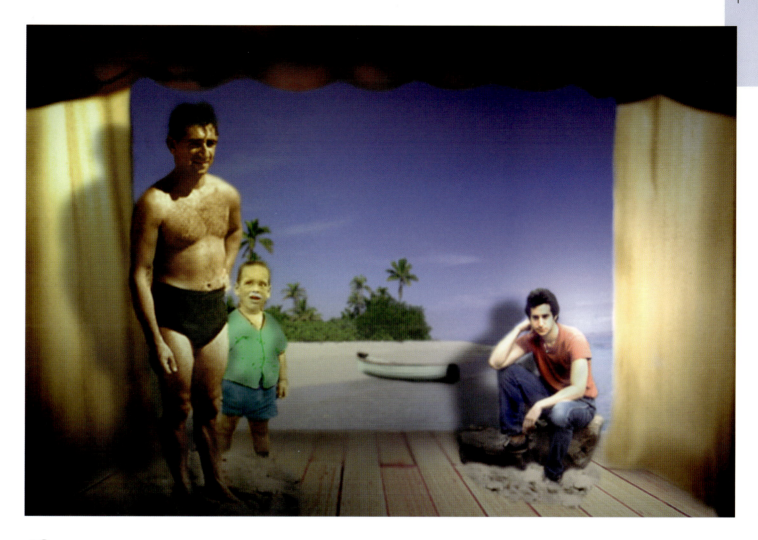

12 Finally, shadows are added to give the picture elements a real presence within the picture. In nature the variety and nuances of shadows is infinite. But in essence there are four basic types: harsh or dark ones as seen here, indicating a bright light source; light-colored ones, signaling a softer light; hard-edged, meaning the object casting the shadow is close to whatever the shadow is falling on; and soft-edged, pointing out, conversely, that the shadow has traveled a greater distance.

In this little drama, *A Day at Rockaway Beach*, harsh shadows were used to give the visual clues of a sunny day. A shadow was intentionally cast on the background, so there's no doubt that this was intended to be a picture of a stage setting.

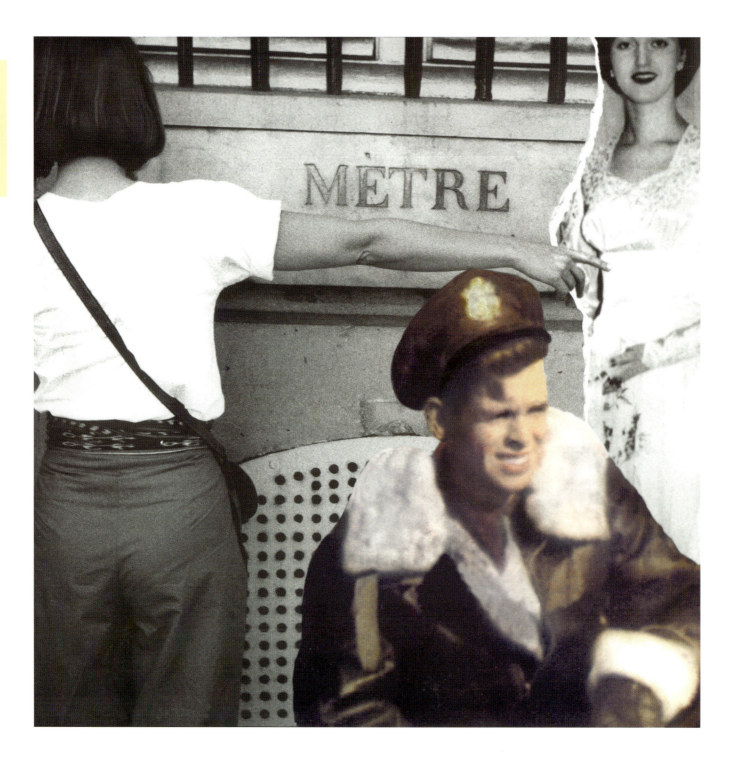

Acquiring Pictures Mechanically

Project

Assembling an illustration for a compact-disc jewel box, in the process demonstrating the technique of mechanically acquiring pictures. Using mechanical methods, two picture elements and a base picture were combined to make the mock-up. The CD comprises songs from the 1940s.

opying artwork mechanically—with a camera—is a tried-and-true way of duplicating or resizing valuable pictures. However, artists preferring the directness of working mechanically need not be left out of the digital revolution. State-of-the-art image-replicating machines provide anyone an easy way to collect images for making a mechanical mock-up, and at the same time provide cropping and resizing capability.

As digitally created images become more prevalent, artists must use techniques, new *and* old, that keep their work looking fresh. For that reason a simple mechanical mock-up was chosen to express the sentiment of this CD titled *Remembrance and Rhythm: Measure by Measure*. A scrapbook-like, cut-and-pasted effect "tells the story" of the music on the CD. The base picture with the word "metre" was chosen because it creates a double entendre with the title.

At left is the mock-up as it appears before the text was added.
The completed picture is presented on page 31.

Materials and Tools

- A cropping device (designed for scaling photographs)
- Markers: two or more colors (designed for writing on acetate)
- Clear acetate
- Ruler
- Camera with polarizing filter and cable release

- 3200° lights with stands and mounted polarizing material
- 18-percent gray card
- High-tech copy machines (available at better photographic specialty stores)
- Metal copy board and magnetic strips

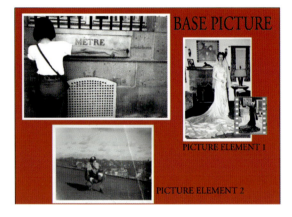

Cropping and sizing

1 This project began with an oversized base picture, a small family snapshot, and a negative of a bride facing the wrong direction. When building a picture, it's easier to find the images that work well thematically and worry about their size later.

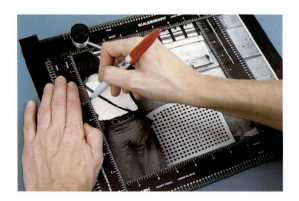

2 Use a cropping tool such as the one shown to determine the portion of the picture to be cropped, while at the same time maintaining the aspect ratio of the chosen format. Using a marker, draw the cropping marks on the base print—in this case the square format of a CD box.

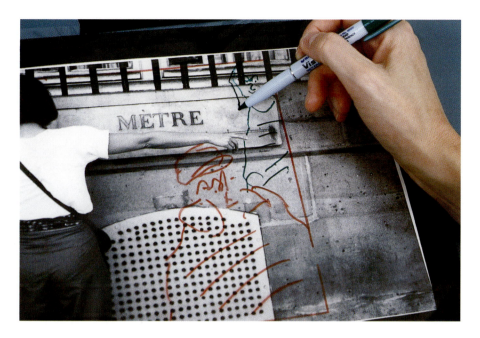

Planning the design

3 Tape the base print onto a piece of mat board and then tape a sheet of clear acetate over it. Use water-soluble markers that are designed for writing on acetate to rough out the composition. Choose a different color marker for each picture element, providing an easy-to-follow, map-like sketch.

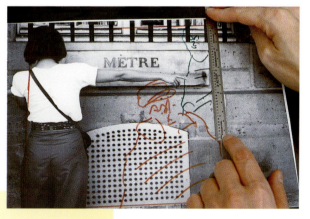

4 Once the size and placement of the picture elements have been determined, use a ruler to measure their sizes. Make sure the picture element is usable in the size required (see sidebar).

Poor quality in, poor quality out

The quality and type of source material must be taken into account before extreme size changes are planned. Large pictures can be shrunk without a problem, but a small picture will degrade if enlarged too much.

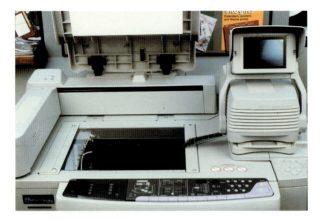

5 The picture of the bride is reversed and printed on a digital copier like this one. Although it may look like the familiar office photocopier, it's actually a high-tech version capable of shrinking or enlarging prints, negatives, or transparencies in color or black-and-white. Machines like this are typically limited to output sizes that are 50–200 percent of the original. The results, though dependent on the quality of the source image, are quite good and are produced on photographic paper in minutes.

6 The mock-up design calls for the bride in the picture to be facing left instead of right. The solution is simply to place the negative in the machine shown in step 5 emulsion side up, to reverse the final print. This has no effect on the quality of the output.

7 Digital workstations like this are becoming a common sight in photographic specialty stores. These machines are designed to offer a "point-and-click" approach to digital imaging. Though more limited than a high-level graphics program run on a standard computer, they can increase or decrease the size of prints in incremental steps, crop, and do minor color and density corrections. A photographic print is delivered in minutes.

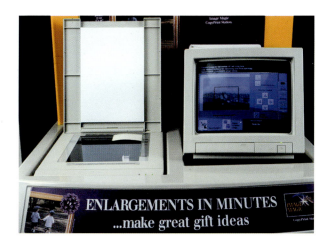

8 Using the photocopier shown in step 7, the original print shown in the left corner is cropped and enlarged. The size of the man in the new picture corresponds to the measurements determined in step 4. This procedure is completely harmless to the original.

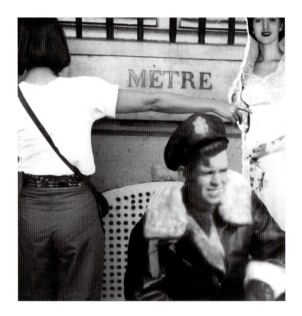

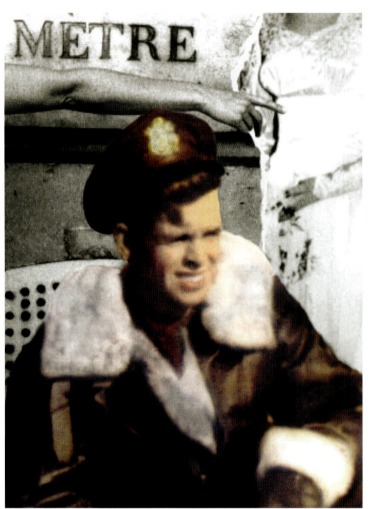

Back to basics

9 Instead of being cut with a knife, the picture of the bride is torn, leaving an obvious white edge indicative of a tear. The hand of the woman in the base picture is cut and the torn picture slipped beneath it. Next the man is cut and pasted in the foreground, on top of the other picture element. Finally, the man is hand-colored.

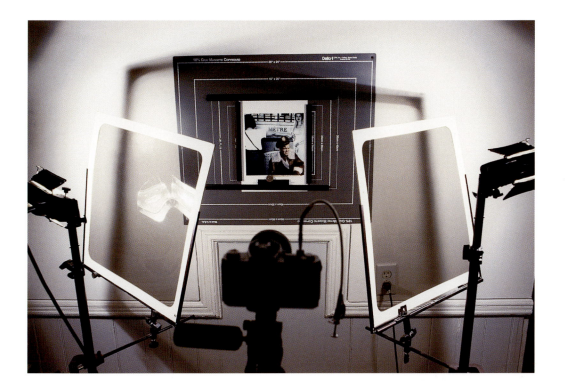

Copying work mechanically

10 By re-photographing the mock-up you get a smooth surface and a means for easy duplication of the image. Attach the mock-up to the copy board using magnetic strips. Place two 3200° lights on light stands at a 45-degree angle facing the copy board. Attach 18" (46 cm) pieces of mounted polarizing material to filter holders designed for this task. Now place a camera on a tripod, with a cable release and polarizing filter, directly in front of the print. For this project transparency film balanced for tungsten lighting was used. A 50-mm macro lens is usually ideal (100-mm lens if copying a small image) because it is designed for photographing flat-field work like this. Note: This procedure is the same, whether you're copying picture elements or finished artwork to produce slides.

Horizontal or vertical?

Vertical copy stands will work, but they limit the size of the print being copied. That's because their lights are usually attached, and the camera can only be moved a short distance from the print. With a wall-mounting system the lights and the camera can be moved in or out to accommodate pictures of varying size.

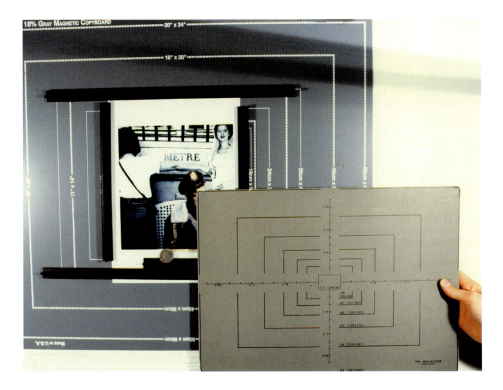

11 Attach the print to the copy board using magnetic strips. Place a silver-colored coin in front of the print and turn the polarizing filter on the lens until the coin looks dark through the camera's viewfinder. Now set the aperture about two stops down, and determine the shutter speed by holding an eighteen-percent gray card in front of the camera and using the built-in light meter to obtain the reading. Note: If you're using a hand-held meter, open the camera's aperture one and a half stops more than the meter reads to compensate for the polarizing filter.

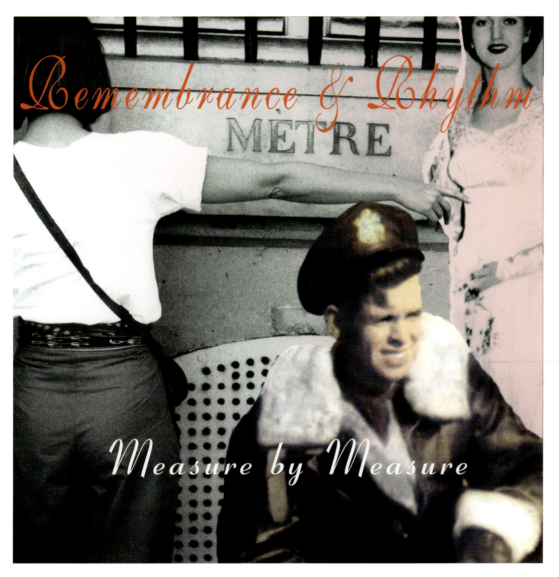

12 The resulting transparency is sent to a prepress designer, who scans it into a computer. The text and colored gradient are added at that time.

Other Techniques Used in This Chapter

- Hand-coloring
- Creating a mechanical mock-up
- Acquiring pictures digitally

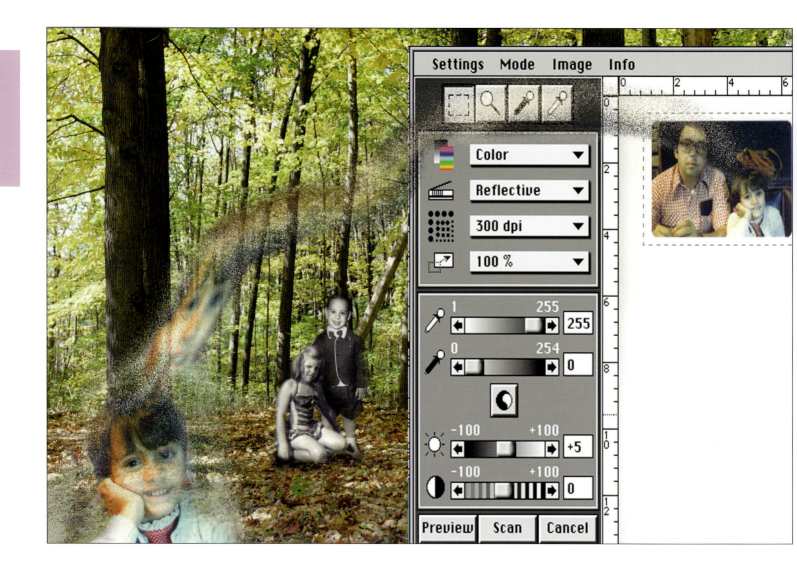

Acquiring Pictures Digitally

Project

Creating a cover piece for a family album, in the process demonstrating the technique of digitally acquiring pictures. Several picture elements and a base picture were obtained through various sources for the mock-up. The montage that results, a multi-generational "family forest" picture, was assembled digitally.

Until the invention of photography, the options for producing pictures, painting and drawing, remained basically unchanged throughout history. Digital imaging has taken photography's basic attributes—repeatability and easy storage of information—and amplified them to almost limitless proportions. Digital images are easy to transport, duplicate, and print, because they exist in the form of computer code, unhindered by a predetermined physical form.

The concept of this picture, the "family forest," grew from the often-used metaphor of a family tree. A forest seemed a better representation than a single tree would be of the depth and diversity families always have. In this scenario ancestors are placed further back in the picture and recent offspring in the foreground. There's always room in the forest for new family members.

The photomontage at left shows parts of the scanner interface and the family forest picture. It depicts the almost magical process by which scanners convert hard copy to pixels and back to pictorial information.

Materials and Tools

- A computer system: minimum 32MB RAM, 100MB free hard drive space
- Adobe Photoshop: available for Macintosh, Windows, or UNIX systems
- Flatbed and film scanner (scans can be ordered from a service bureau)
- CD-ROM player and CD-ROMs with royalty-free photos

Pixel source = picture source

1 Acquiring pictures digitally enables artists to gather pictorial information from virtually any source. For this project black-and-white and color prints, transparencies, and negatives, along with a CD-ROM, were used as source materials for the base picture and picture elements.

2 CD-ROM players have become so common that they're frequently built right into a computer's housing, as seen in the illustration. They offer fast access to great amounts of information. Each CD-ROM has more than 600 megabytes of information, or the equivalent of about 200,000 typed pages. Of course, storage capacity and speed of these devices is constantly increasing.

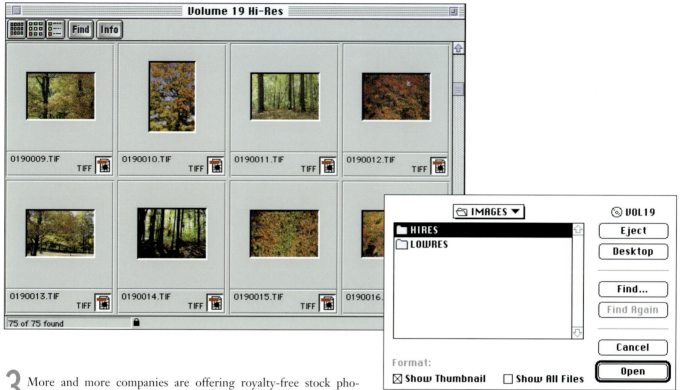

3 More and more companies are offering royalty-free stock photographs on CD-ROMs. Due to the large number of pictures each CD-ROM contains, browser software lets users quickly and easily thumb through the contents. (Browser and CD-ROM images courtesy of MetaTools Power Photos)

Choosing an image resolution

Often CD-ROMs contain the same pictures in two sizes or resolutions. Larger files usually contain about 300 dots per inch, and smaller files generally have 72 dots per inch. The lower-resolution pictures are faster and easier to work with, but they're suitable mostly for things like World Wide Web pages. A hi-res image was used for the base picture in this project, allowing the final piece to be printed full-size on a dye-sublimation printer.

4 Typing [Command-O] [Windows: Ctrl-O] in Photoshop brings up the Open dialog box. Select the image you want to use and click the Open button.

5 Operating a flatbed scanner is similar to using a photocopier, but instead of producing a hard copy scanners convert analog pictures into digital form. This transformation allows computers to understand and work with pictures.

Improving the quality of scans

Scanners should be kept clean inside and out. The mirror near the bulb should be kept spotless and the bulb changed periodically.

6 Flatbed scanners usually come with both standalone software applications and Photoshop plug-ins that allow you to acquire scanned images directly from Photoshop. The software varies with each brand, but essentially all programs offer similar features. The operator chooses the appropriate image type (color or grayscale) and then, based on a quick preview scan of the image, sets the size of the scan (measured in dots per inch), adjusts the tone controls (brightness, darkness, and contrast), and crops the image. The illustration shows a marquee around the girl indicating which portion of the print will be scanned.

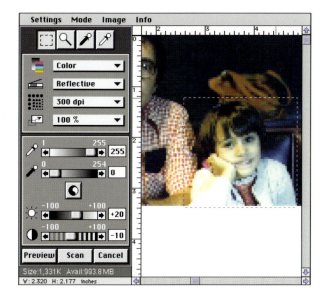

7 Ultimately, fine corrections in color and contrast are best done in Photoshop. However, it's essential to start with a well-scanned picture—non-existent details can't be added or corrected later. Using the scanner software's automatic exposure button is easy, but it results in the loss of portions of the highlight and shadow detail. Instead, use a curves adjustment tool in the software provided with the scanner to correct the preview scan. After scanning, use the Levels command in Photoshop for the final adjustments.

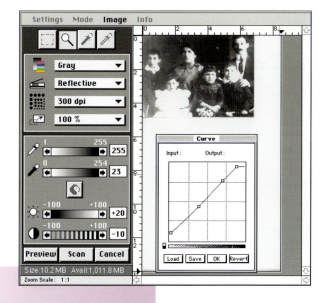

Sharpening: the final step

After final corrections have been made to a new scan, apply the Unsharp Mask filter in Photoshop.

8 A film scanner like this is ideal when very high-resolution scans aren't necessary. It will scan any kind of 35mm film and was used to make the family forest picture.

Scan high, save low

Scan your images at a resolution higher than necessary, then resize the image down in Photoshop. This will assure that the maximum amount of information is captured.

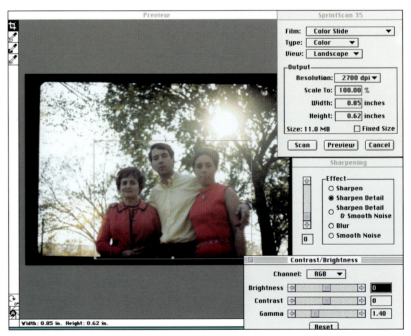

9 As with flatbed scanners, each film scanner offers a different software interface. Again, the options generally boil down to contrast, brightness, midtone correction, focus, and file size (dpi). Additionally, with film scanners, a film type needs to be chosen. Changing the type and brand of film will affect how the software interprets the color of the film being scanned—use the setting that matches the film type being scanned.

Saving files

There are a few common formats in which to save a file. Most output devices will work with a TIFF file, but some may prefer that the file be saved in EPS format. Check with the service bureau doing the output in advance, but don't fret, because most will re-save the file in their preferred format.

10 After each scan, pressing [Command-S] [Windows: Control-S] brings up Photoshop's Save dialog box. Since the family forest picture uses several picture elements, it is saved as a Photoshop file because that's the only file type that allows the use of layers.

11 Service bureaus offer high-resolution scans done on scanners like these. The scanner on the left is the most common type of film scanner found in service bureaus; the one above is a high-end drum scanner used to make books like this. Note: As a point of reference, the maximum file size of a 35mm transparency scanned using the machine in step 8 would be about 28 MB, the one on the left about 100 MB, and the scanner at right about 900 MB.

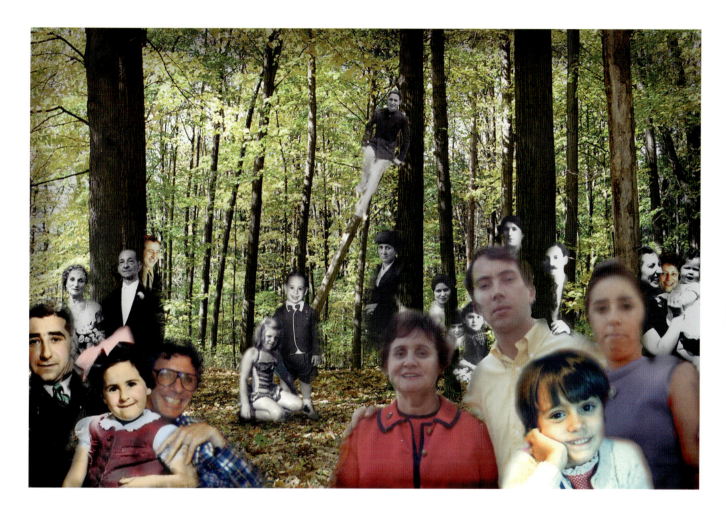

Digital cameras

12 The family forest picture was assembled as a digital mock-up, discussed in detail in Chapter 5. In the future people will make their family snapshots with digital cameras. At this time, the best digital cameras are very expensive (in Chapter 10 the illustrations for steps 8 and 9 were done with a $30,000 camera). For now, scanning old snapshots to produce a family forest picture is a metaphor for linking the best of the past with the best of the future.

Other Techniques Used in This Chapter

- Creating a digital mock-up
- Digital retouching

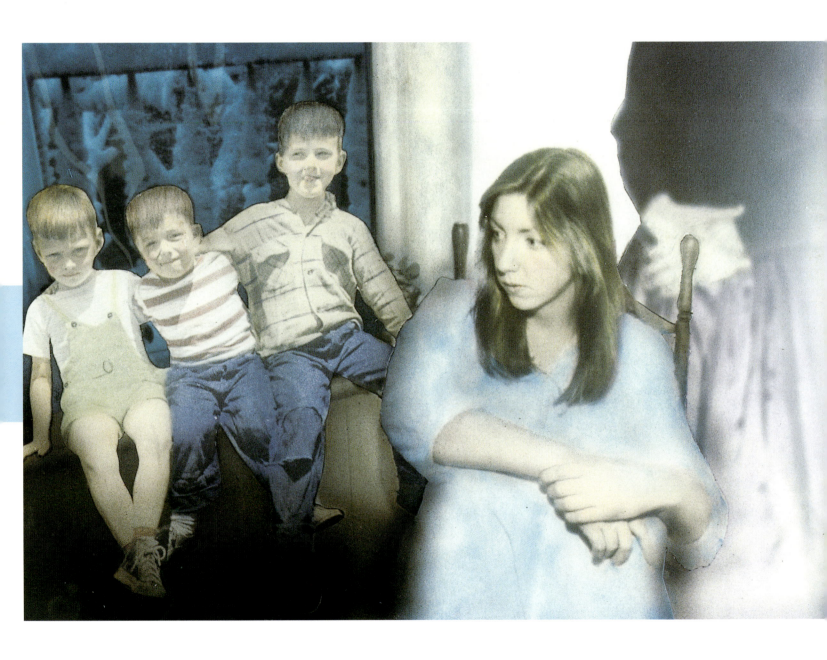

Creating a Mechanical Mock-Up

Project

Showing photomontage as visual metaphor and demonstrating the technique of making a mechanical mock-up. A base picture and two picture elements were glued together to form the montage. The resulting mock-up was scanned into a computer, re-worked in Adobe Photoshop, and output on watercolor paper.

For some artists, staring at a computer screen will never replace the tactile sensation of working with actual pictures. Although the technical necessity of cutting and pasting pictures mechanically may have passed with the advent of computer graphics, the technique has moved well into its second century—and still has many applications.

Designed as an illustration to accompany a short story, this project metaphorically portrays how, as individuals, we face the past while the future looms over our shoulders. It juxtaposes visuals representing the past, present, and future. Although making this picture digitally would have seamlessly integrated the elements, working mechanically tends to betray the artist's hand; it leaves no uncertainty which elements the artist chose to combine. The viewer is inspired to question why the elements were placed together, and what it means as a whole.

Shown at left is the mock-up of *Something Old Something New*, hand-colored, with added airbrush touches to fade the picture elements into the background. The finished montage can be seen on page 49.

Materials and Tools

- Self-healing cutting mat
- Craft knife
- Sandpaper (very fine grit)
- Sheet of glass at least 1/4" (.5 cm) thick (rounded edges preferred)

- Small dish (for water)
- Black marker
- Rubber cement (white glue can be substituted)
- Small brush (for applying rubber cement)

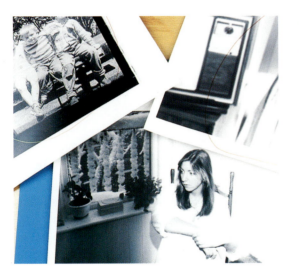

Cutting pictures

1 Begin by choosing a base picture upon which picture elements can be glued. Together they will make a working mock-up, suitable as a final print or for re-photographing. Put some thought into selecting a set of pictures that will communicate your concept. Think about the proportion and tonality of the picture elements when combined with the base picture. Try not to combine mismatched elements, which can lead to "unreadable" pictures. This process of planning the final image is an important step in producing the picture elements. For this project, the headless figure on the right was lightened, and the picture of the three boys was printed with low contrast to help convey the right mood—even before any cuts are made.

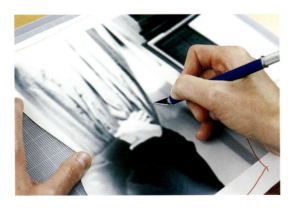

2 Place the picture elements on the cutting surface. A self-healing cutting mat is vastly superior to mat board; when making precise cuts on mat board, the blade is easily swayed by gouges in the underlying material. Always cut with the knife blade leaning at a 45-degree angle to the inside edge of the image. This is to keep white edges from showing on the picture elements after they are glued to the base picture. As you cut, turn the picture to retain the same angle.

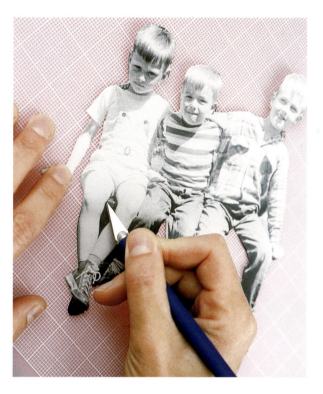

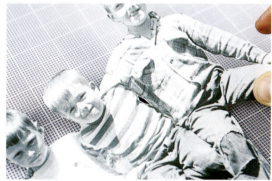

3 Cut out the small areas, maintaining the same 45-degree angle with the knife blade as shown above. Above right, the image shows a white area between the boys, an example of a picture cut from the wrong direction. Try to do it right the first time; if the wrong cut is made, however, it can be fixed in the next step.

Working with picture elements

With a mock-up, the goal is to cleanly integrate the picture elements with the base picture. Picture elements that are too thick will create shadows when the mock-up is photographed, requiring cleanup when scanned. Equally important, if the mock-up will be the final piece, an unbroken surface is desirable.

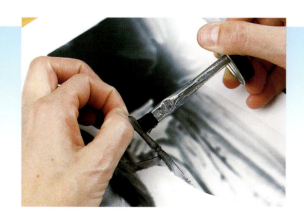

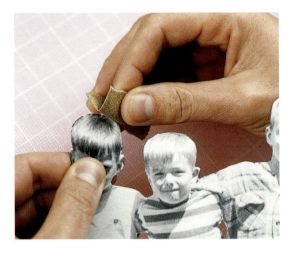

Sanding the edges

4 Remove burrs and white areas by carefully sanding the edges of the picture elements with a careful, downward stroke. Go slowly; the idea is to make the edges smooth. Roll a small piece of sandpaper tightly to get into close areas; for large, straight edges, use a flat section of sandpaper.

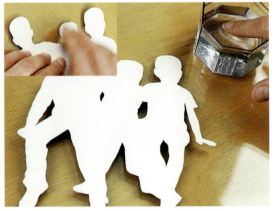

Flattening the picture

5 Place the picture elements on the glass. Wet your finger with water and dampen a small section on the back of the picture. Sand in a circular motion, removing as much of the paper backing as possible without going down through the emulsion. As the print begins to thin, use your finger—instead of the sandpaper—in a rubbing motion to avoid damaging the emulsion. Keep the glass clean and dry to prevent the emulsion from sticking. Repeat these steps as needed, paying particular attention to the edges.

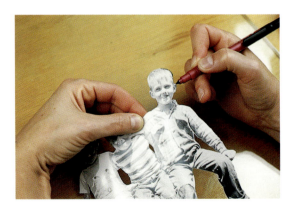

Finishing the edges

6 To help picture elements blend in with the base picture, darken the edges of the picture elements that will be against a dark background in the base picture, using a permanent black marker. Remember to darken the small, tight areas where the rolled sandpaper was used as well as the larger, more obvious edges. Note: Do not darken edges that will lie against white areas.

Looking beyond the surface

7 Examine the composition by placing the picture elements against the base picture. Consider how the elements will look together in three-dimensional perspective. A picture element is perceived to be in the foreground when it covers something; to create that effect, slits must be cut in the base picture large enough to allow background objects to slide behind those in the foreground. In this case, the leg of the boy on the right will be slid behind the woman's left shoulder, and the headless figure will be slid behind the woman's right shoulder and arm.

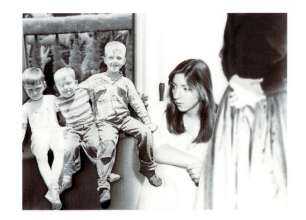

8 Determine where the foreground will overlap the background. Cut slits in the base picture large enough to accommodate the elements that will be slid behind them. Follow steps 1 through 6; sand the edges and flatten the picture. When that is done, turn over the base picture and flatten the areas that were cut. Darken the edges of the overlapping foreground areas with a marker, as in step 6.

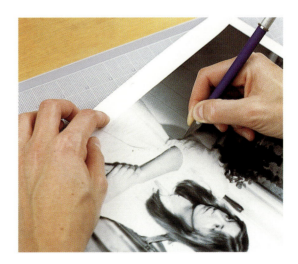

9 As a final check of the composition before gluing the mock-up, place the picture elements back on the base picture and slip them under the cuts as planned.

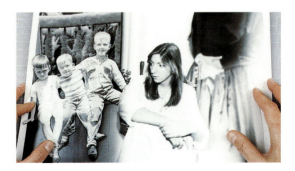

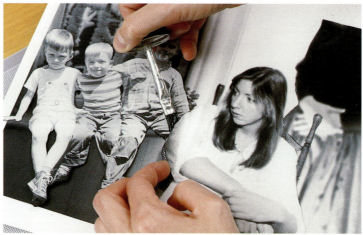

10 With the small brush, apply glue to the back of picture elements and place them in position on the base picture, smoothing them down with your fingers. After that, apply glue to the underside of overlapping elements. Finally, apply glue to the back of the entire mock-up, and place it on a piece of mat board larger than the mock-up to prevent curling when applying color, or for photographing and framing.

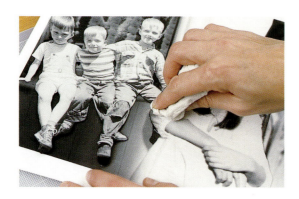

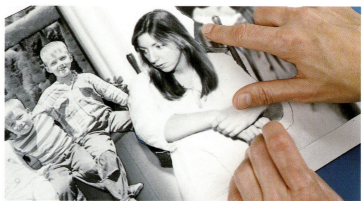

11 Press the pieces into place until the glue sets. Once the glue begins to harden, use your finger and a paper towel to clean up the excess. Place the mock-up under a heavy object, such as a book, to dry.

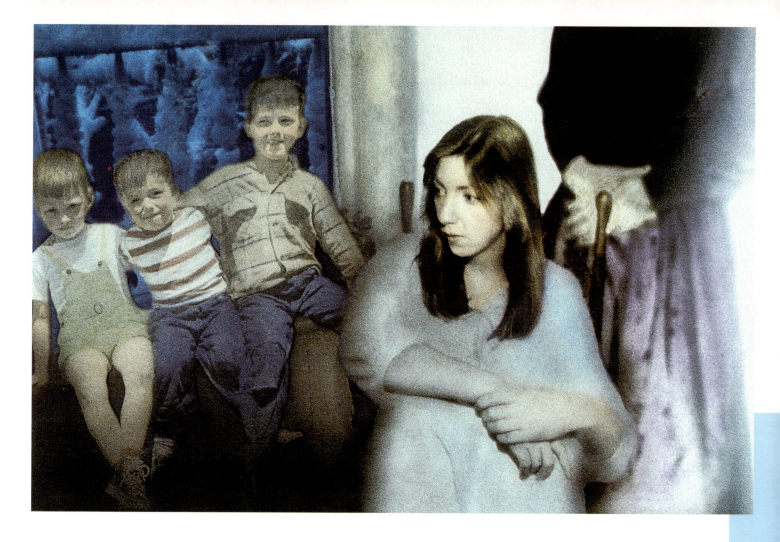

In *Something Old, Something New,* the choice of output was digital; after scanning the mock-up, it was printed on watercolor paper with an inkjet printer. Many options are available to the designer for the final print, from darkroom printing to several electronic printing technologies, but keep in mind that the output means should complement the image. For this project, the choice of paper was consistent with the intended feeling of the picture.

Once the mock-up was created, digital techniques were employed to give the final montage a more painterly look. Before final printing, the mock-up was scanned and opened in Photoshop. Using softening and Gaussian blurring, the edges around the figures were cleaned up, and the color and contrast were adjusted. These steps solidified the picture elements with the base picture while maintaining the properties of a mechanical mock-up.

Other Techniques Used in This Chapter

- Hand-coloring
- Airbrushing
- Acquiring images digitally
- Digital retouching

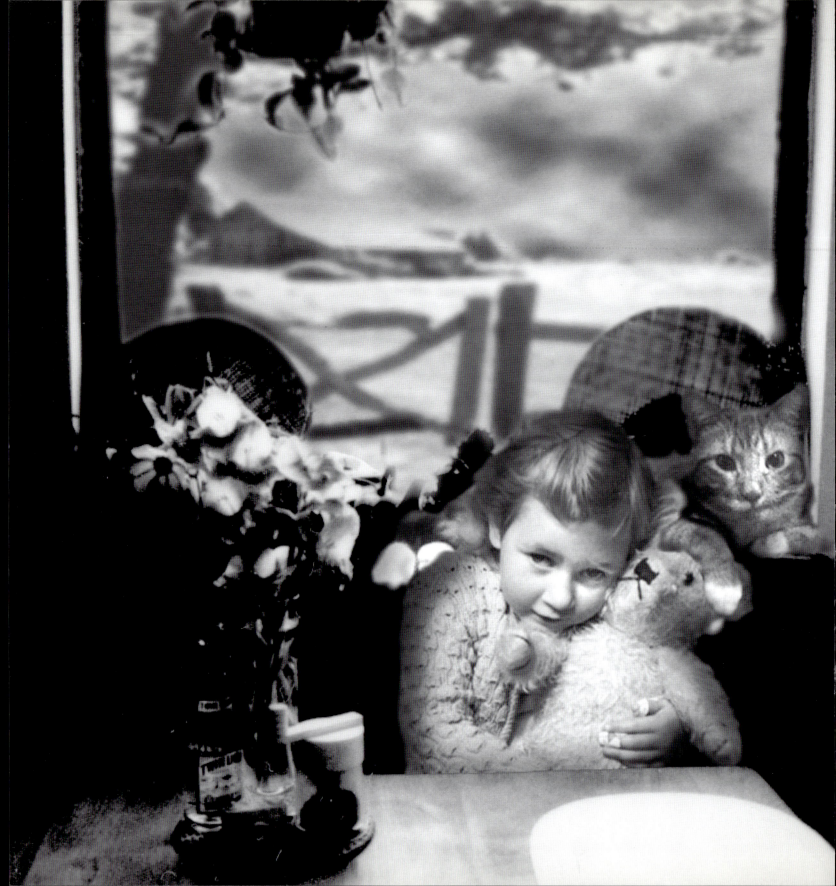

Creating a Digital Mock-Up

Project

Creating an illustration for an imaginary children's book, in the process demonstrating the technique of making a digital mock-up. Three picture elements and a base picture were acquired and combined digitally; the resulting picture was output as a black-and-white dye-sublimation print and hand-colored.

Whether the artist is starting with digital image files from CD-ROMs, scanned photographs, or transparencies, the computer offers an unprecedented palette of creative options. This chapter shows the computer's unique ability to combine photographs, linking the freedom of a paintbrush with the realism of a camera.

Created as an illustration for a children's book, *Good Friends at Home* recalls a bucolic childhood memory. Digital techniques were used to control depth of field within the photomontage. The window—showing a view of a picturesque landscape—appears as a hazy backdrop, emphasizing the warmth and comfort of the foreground elements: the cat, teddy bear, and girl. Working digitally allowed for a smoother transition between the picture elements and base picture than possible with mechanical methods.

Shown at left is the mock-up for *Good Friends at Home,* output as a black-and-white dye-sublimation print. The final hand-colored version of the montage is shown on page 57.

Materials and Tools

- Computer system: minimum 32MB RAM, 100MB free hard drive space
- Adobe Photoshop: available for Macintosh, Windows, or UNIX machines
- Scanner (scans can be ordered from a service bureau)
- Dye-sublimation printer (prints can be ordered from a service bureau)

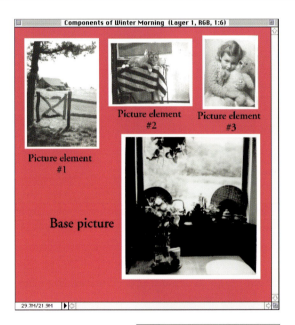

Picture element #1

Picture element #2

Picture element #3

Base picture

Preparing picture elements

1 Choose a base picture and picture elements, as with the mechanical mock-up. Unlike the mechanical method, working digitally allows for the ability to modify the size and contrast of the picture elements while composing the mock-up. Scan the base picture and picture elements at 300 dpi (see Chapter 3); the scans should have as much detail as possible. Each picture should be scanned individually and saved as a separate file. At left, the components are shown together for illustration purposes only.

Planning the composition

Whether creating an abstract or literal photomontage—*Good Friends at Home* is the latter—forethought in choosing your pictures is essential to expressing your ideas. A carefully composed montage contains picture elements that work together to tell the story, and looks aesthetically pleasing.

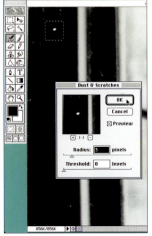

2 Inspect the newly scanned images for small spots resulting from dust and "scan noise" (blemishes that the scanner sees but that aren't really there). These can be eliminated several ways, but using the Dust & Scratches filter is quick and simple. The filter should be applied to a small, selected area around each spot. Double-clicking on the Zoom tool will enlarge the image on the screen to a 1:1 magnification, making it easier to work on details.

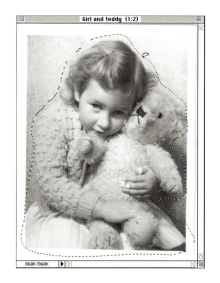

Cutting pictures

3 Cut out the picture elements with the Lasso tool. Make a rough selection around the portion of the picture to be used in the photomontage. Add or subtract from the selection by pressing [Shift] or [Command], respectively [Windows: Shift and Ctrl], while using the Lasso.

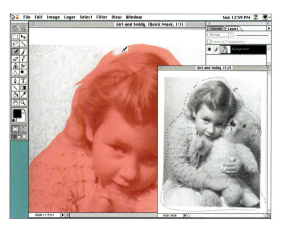

4 Once the rough selection is complete, click on the Quick Mask button to cut the pictures more closely. The current selection will be shown in red. The Airbrush tool can be used to add or subtract from the selected area. When working on the smaller contours of the selection, choose a brush size that will restrict the masking to the area desired. Pressing the "X" key will make the foreground color alternate between black and white. White will remove portions of the Quick Mask; black will add them. When the Quick Mask covers only the area to be cut, press Q to reveal the final selection. The selected picture element is now ready to be placed in the base picture.

The Quick Mask advantage

The Quick Mask feature of Photoshop is the easiest technique for building a complex selection; it allows for precise, trial-and-error adjustments without fear of unintentionally deselecting a complex path.

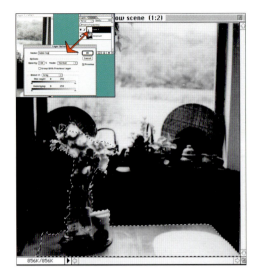

Combining elements and base picture

5 Select a portion of the base picture intended to show in the foreground. Press [Command-J] [Windows: Ctrl-J] to float the selection. In Photoshop 3.0, double-click on the "Floating Selection" item in the Layers palette to make the selection a new layer and give it a name; Photoshop 4.0 will automatically make the selection a layer, so only the name will have to be changed by clicking on the new layer, thus bringing up the Layers option box. Name each layer after its content; this makes it easy to keep track of what's in a layer when switching among them on the Layers palette. In this case, the new layer is named "table top."

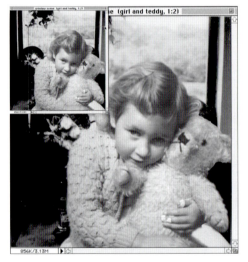

6 Drag the selection—in this case the girl and teddy bear from step 3—into the base picture using the Move tool and name the new layer (for this project "girl and teddy" was used). With the new layer selected, use the Scale command to adjust the size of the picture element to fit the composition and place the picture element in position with the Move tool.

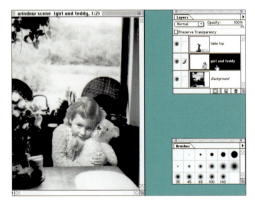

7 Move the girl/teddy bear picture element "under" the table layer by dragging the "girl and teddy" layer below the table top layer in the Layers palette, which re-establishes the tabletop as the foreground. Now the girl will appear to be sitting behind the table.

Keep it simple

In computer graphics, there are usually several ways to perform the same task, such as placing a selection within a picture using the Move tool or cutting and pasting. Familiarity with alternative methods is useful, but it can unduly complicate the process of working digitally. It's best if artists restrict themselves to one or two methods for each procedure. This will allow for a more creative, free-form use of this technological medium.

Inserting a second picture element

8 Select the next picture element—the cat—and drag it into the base picture. In the Layers palette, change the layer order by dragging the "cat" layer below the "girl and teddy" layer to make the cat appear behind the girl in the picture. Scale the cat to the appropriate size. Next, select the cat's front paw, convert it into a layer as in step 5, and place it in front of the bear's head by dragging the paw layer above the "girl and teddy" layer in the Layers palette.

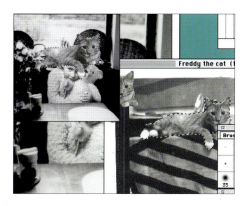

9 Select each layer and use the Levels command to adjust its contrast to match the base picture. Use the Blur tool to soften the edges of a selected layer. Using the Burn tool on the edges of a picture element creates a sense of natural light fall off on the object. Note: For the purposes of photomontage, the term "light fall off" refers to the way light drapes over a rounded object. Gradually darken toward the outer edge of the picture elements to create this effect. Controlling this effect photo-mechanically, digitally, or with an airbrush, will prevent picture elements from looking like flat cut-outs on the base picture.

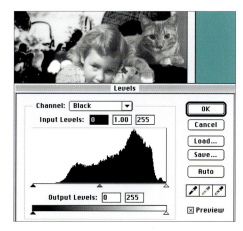

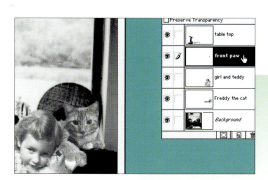

Conveying depth

Small details such as placing one picture element on top of another—in this case, the cat's paw—produce a sense of depth. The "cat's paw" layer was moved, as in step 7, above the "girl and teddy" layer on the Layers palette to place the paw on the bear's head.

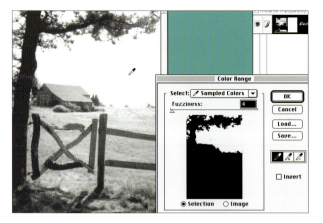

Creating the background

10 Select a picture—in this case, the farm landscape—and copy it to the clipboard. Then select the window in the base picture with the Lasso and Quick Mask. Paste in the farm landscape using the Paste Into command. Name the layer (for this project, "farm pic" was used) and scale it to size as in step 6. Select the sky area of "farm pic" with the Magic Wand tool; this is a fast way to make a rough selection when the area is uniformly colored. Quick Mask was used, as in step 4, to precisely adjust the selection around the tree leaves.

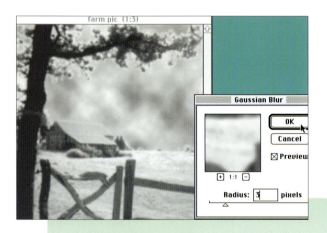

11 Next, apply the Clouds filter to produce a dramatic sky in the selection from step 10. Finally, a Gaussian blur is applied to the "farm pic" layer, which keeps the emphasis on the foreground. Once the work is completed on each layer and the picture looks correct, choose Flatten Image from the Layers palette menu, condensing the layers into a single image. After saving in EPS format, the image is ready for printing.

Save a backup

Once the merged picture is saved, the individual layers are no longer accessible. To retain the original Photoshop file with layers, save your file, then use the Save As command to create another file whose layers can be merged. When the Save dialog box pops up, type "merged" after the original file name to differentiate it from the original.

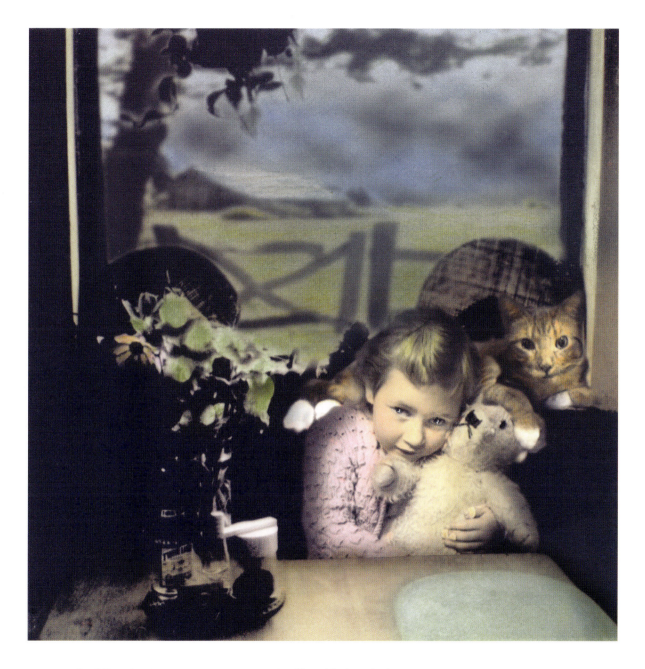

Good Friends at Home was output as an RGB file in black-and-white on a dye-sublimation printer. The final piece is shown hand-colored, with a light gray haze airbrushed into the background.

Other Techniques Used in This Chapter

• Hand-coloring

• Airbrushing

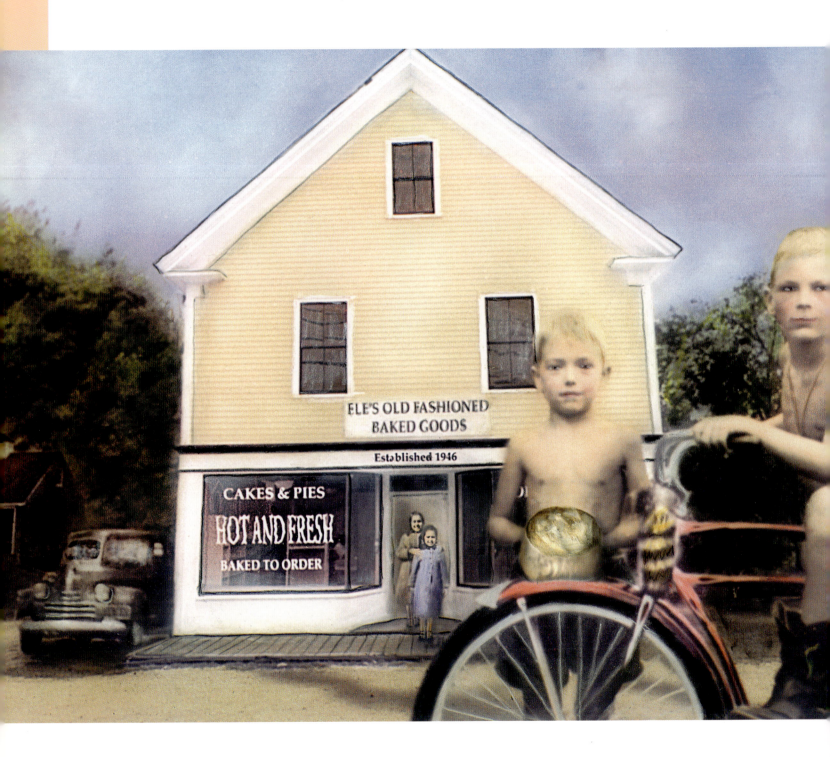

Hand-Coloring a Black-and-White Print

Project

Creating an illustration for a fictional advertisement, in the process demonstrating hand-coloring techniques. A digital mock-up containing six picture elements and a base picture was output as a black-and-white dye-sublimation print. Finally, the picture was hand-colored using photographic oil paint and pencils.

W hen artists began hand-coloring photographs in the 19th century, they never could have imagined this distinctive medium being applied to digitally created images. Yet the following demonstration does exactly that. A question comes to mind: With color film and digital cameras, why hand-color photographs? The answer, however, does not lie in the technique's practicality, but in the aesthetic and creative qualities unique to hand-colored pictures. A tangential benefit of hand-coloring digitally created images is that the process allows the use of smaller black-and-white files that are faster to work with and require less RAM.

Ele's Old Fashioned Baked Goods was imagined as an advertisement for a bakery that wanted to convey in a picture its many years in business. Hand-coloring was especially suited to this need, because when applied with muted colors it imparts an old-time feeling. Additionally, working in photomontage enabled the inclusion of picture elements such as the raccoon tail on the bike and the old car, which help to establish a specific historical time period.

Shown at left is the final hand-colored print, *Ele's Old Fashioned Baked Goods.*

Materials and Tools

- Cotton pads from an art supply store
- Photographic oils
- Toothpicks
- Photographic pencils
- Cotton swabs
- A palette book or wax paper
- Aerosol matte spray

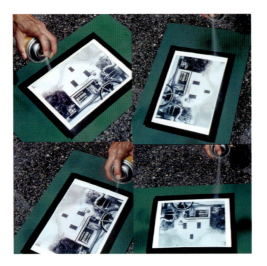

Preparing the surface

1 Any photographic paper can be hand-colored if it has a matte surface; with a glossy or smooth surface the paints will wipe off. This project uses a glossy dye-sublimation print which requires coating with an aerosol matte spray to give the print the texture required for painting. Spray across the print, outdoors or in a spray booth. Allow a few moments for drying, rotate 90 degrees, and spray again until one light coat is applied from each direction. Note: The procedure is the same for conventional glossy photographic paper.

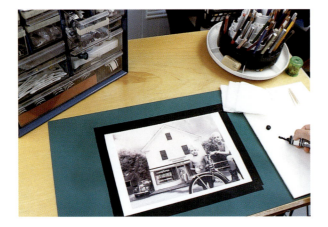

Setting up your work area

2 Place your tools within a comfortable working distance. Use a palette pad or wax paper to hold the paints. It's helpful to write the name of the color under the blob of paint, making a crowded palette easier to use.

Applying paint to large areas

Large areas of paint are applied with long-grained cotton pads from art supply stores (not the type from pharmacies). Brushes consist of cotton-tipped swabs and toothpicks with their tip wetted and the cotton rolled on.

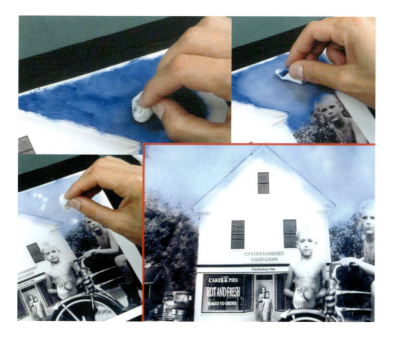

3 Apply the color to the largest areas first. Regular oil paint should not be used unless a thick opaque effect is desired. Photographic oils are translucent and allow the shading and details to show through the color. Rub the paint on lightly, and then gently rub it off. Only a thin layer of color should remain on the print. If a deeper color is desired, repeat this step.

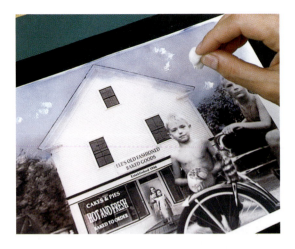

Heightening highlights

4 Avoid flat, unnatural looking areas of color by emphasizing highlight areas. Dab white paint on areas such as clouds, then lightly rub it in to integrate it with the base coat.

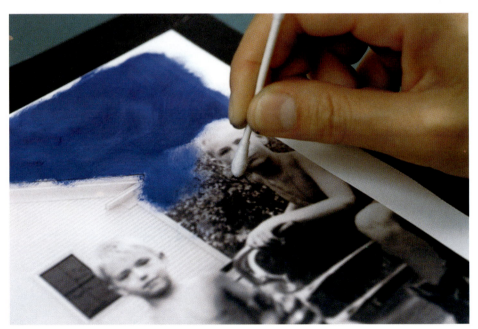

Details are important

5 When painting large areas, don't forget smaller related areas—for example, the sky behind the trees. Use a toothpick brush or swab to place fine amounts of paint.

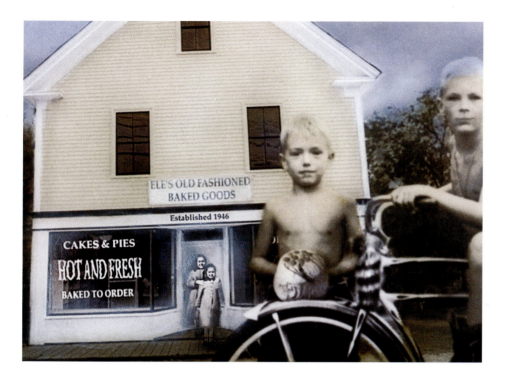

Work your way down

6 Continue to the next largest area—in this case, the building. If an accurate rendition is desired, consider how this scene would appear naturally. Color applied in large areas can spill over into smaller adjoining ones requiring cleaning, so save the details to the end to avoid duplication of effort.

Repairing mistakes

Inevitably paint will end up in the wrong areas; e.g., the roofline in step 6 has sky blue in it. Usually a darker color will cover a lighter one, or the excess color can be cleaned up as in step 8.

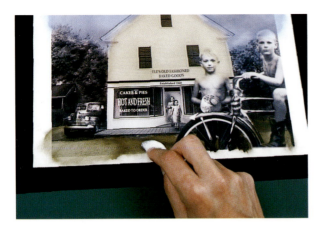

Keep the color even

7 Rotate or replace the cotton wad as you work. Rub gently, but persistently, to leave an even level of paint. A darker area, as in the road in this image, indicates too much paint left on the picture.

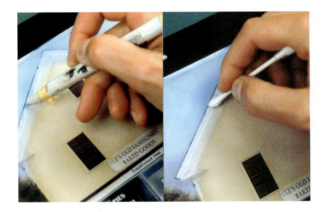

Cleaning up

8 Clean up areas where the paint color has spilled over in one of two ways. First, a sharpenable, pencil-type (or a "kneaded") eraser can be used for fine details. Secondly, some extender can be used on a swab for small areas or on a cotton wad for larger ones. Do not be over-zealous or the matte coating will be rubbed off. Note: This only applies to paper that has been treated with matte spray by the artist.

Painting with ease

Photographers may find the idea of "painting" intimidating. However, this process is simpler than painting on a blank canvas, because the composition and tonality are determined by the underlying picture.

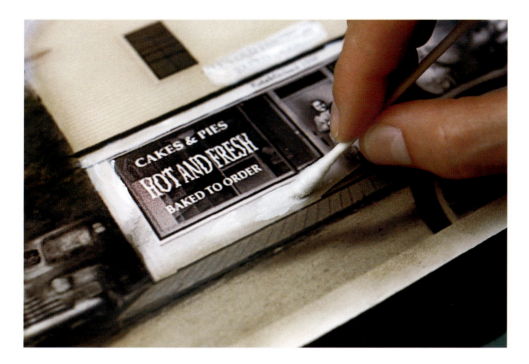

Larger details first

9 Since the trim of the building was to be white, the surrounding dark areas were done first. Keep in mind, it's easier to retouch a dark area where light color paint has spilled over than the alternative.

Pencil points

10 Photographic pencils marks are used to smooth out color without leaving telltale marks; detailed areas would be very difficult to color with just paint. In this image, a pencil was used on the sign background to minimize cross-coloring in the letters.

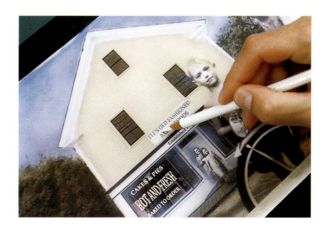

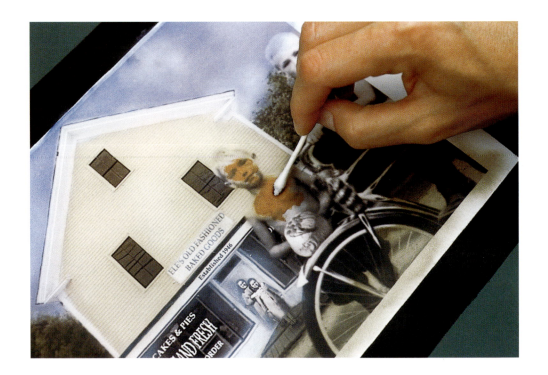

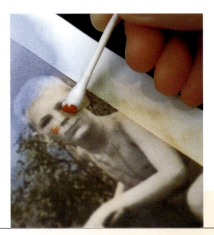

People in pictures

11 Apply the skin tone as a base coat wherever appropriate. Eyes, lips, and other details are cleaned and painted in step 12. After applying the base coat of skin tone, add some pinkish color to the cheeks to add depth to the skin color.

Skin shades

There is no single flesh color. Basically, all flesh tones are shades of brown. Some photographic oils simply are labeled flesh 1, 2, and 3 to indicate darker and lighter hues. Skin tones will look more natural—and less flat—if two different shades are blended together. Use one color as a base, with a slightly darker hue in the shaded areas.

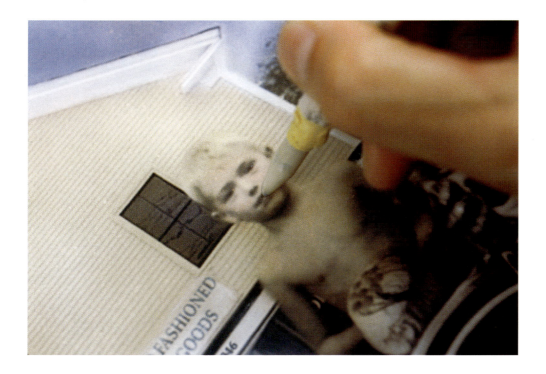

Finishing up

12 Once larger areas are colored, details such as eyes, lips, or lettering are cleaned as in step 8. If the eyes and lips are small, use pencils, rather than paint, to color them in. Pencil in the whites of the eyes, because life-like eyes make the face more compelling to look at. If the eyes are large enough, use a toothpick tip to place a tiny dot of white paint in each pupil. When the coloring process is completed, the picture may be framed, re-photographed, or scanned into a computer. The completed picture is seen on page 58.

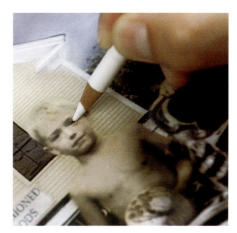

Other Techniques Used in This Chapter

• Acquiring pictures digitally

• Creating a digital mock-up

• Outputting to paper

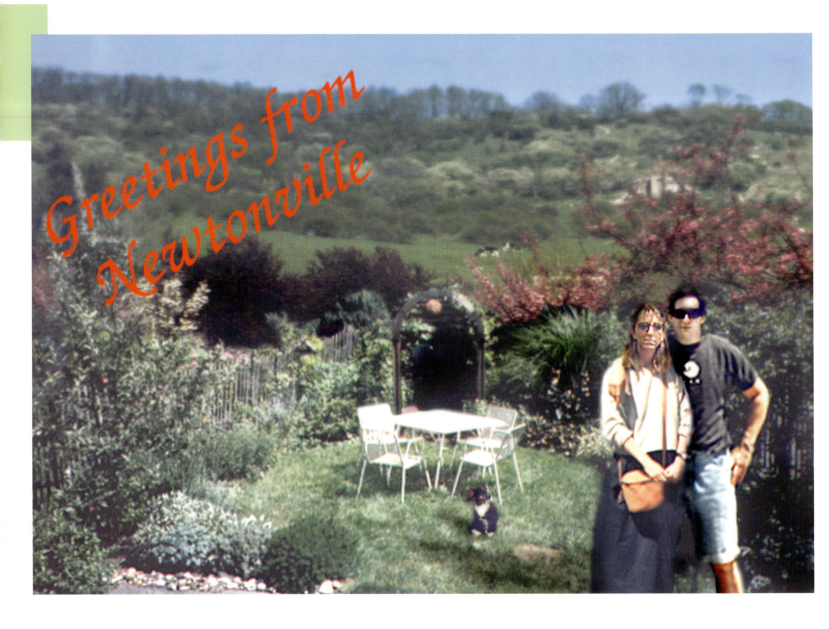

Greetings from Newtonville

Applying Photographic Controls Digitally

Project

Making a faux postcard, in the process demonstrating how to apply traditional photographic controls in Adobe Photoshop. Six picture elements and a base picture were combined The resulting digital mock-up was output as a 4K negative; multiple prints were made at a conventional photographic lab.

It could be said that digital imaging is where science and magic meet to become a new artistic medium. With a computer, the content of a photograph is no longer limited to the momentary circumstances of its creation. Depth of field, focus, and exposure—formerly limited by film, lenses, and light—can be changed digitally. From now on, the "decisive moment" ends only when the photographer wants it to.

Homemade postcards have been around for a long time, from black-and-white prints with a simple address section on the back to more recent create-a-postcard labels designed for use on color pictures. With a little digital help, *Greetings From Newtonville* elevates the homemade postcard to a new level. Now anyone can make friends jealous by sending postcards showing themselves in exotic locations. This project is great for fun or as a commercial venture.

Shown at left is the postcard titled *Greetings From Newtonville.*

Materials and Tools

- Computer system: minimum 32MB RAM, 100MB free hard drive space
- Adobe Photoshop: available for Macintosh, Windows, or UNIX machines
- Picture source: a scanner or CD-ROM
- Film recorder (available at a service bureau)

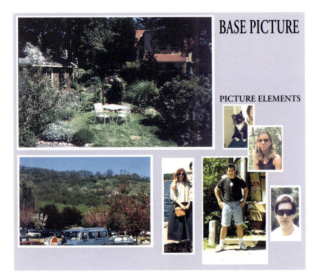

BASE PICTURE

PICTURE ELEMENTS

Creating a scene

1 Keep in mind that in making a fantasy postcard, anything goes in choosing the base picture and picture elements. In this project, artistic license was invoked to replace the suburban backdrop behind the garden with the French countryside. Different heads were attached to the people, and the family cat was included for good measure.

Depth of field

Depth of field is the amount of foreground and background that is in focus, beyond the specific point of focus. In the next step, the foreground is the desired focus point, so the desired effect is a gradual fade out of sharpness toward the background. Normally this occurs because of the physics of optics, but in photomontage this is done intentionally to trick the viewer's eye into perceiving depth.

Faking depth of field

2 To gradually throw the background out of focus, start by clicking on the toolbox's Quick Mask button. Then use the Gradient tool to create a gradient from the bottom up. When finished, the red overlay color should be darkest at the bottom of the picture and fade out toward the top. Press [Q] to revert the selection to "marching ants."

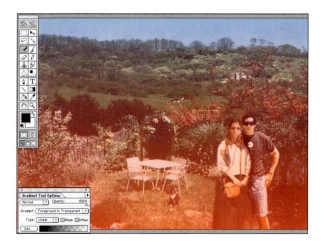

Blurring the image

3 Select the Gaussian blur filter and set the radius to about two pixels. This is contingent on the desired effect—much more and the background will be unrecognizable. Once the filter has been applied, press [Command-D][Windows: Ctrl-D] to end the selection, but don't save the changes yet.

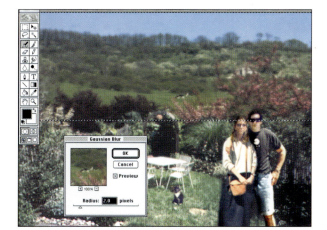

Beyond the blur

The degree of the blurring effect will correspond to the gradient created with the Quick Mask. Consequently, the focus will gradually decrease toward the picture's background.

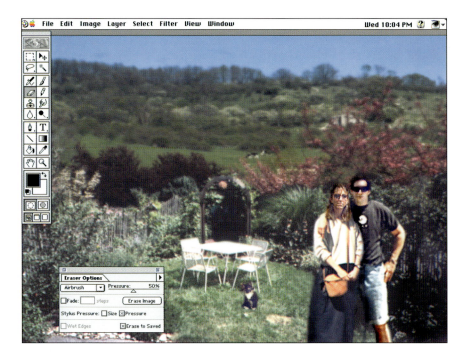

Selective restoration

4 Some of the foreground was caught in the selection in step 3, affecting the focus of the central figures. To correct this, first click on "Erase to saved" in the Eraser option box. Choose an appropriately sized brush and erase to restore the sharpness in the faces and parallel areas. Now save the changes.

Controlling exposure

5 As in step 2, make a Quick Mask gradient from the bottom of the image up. With the new selection made, open the Levels dialog box. The goal is to convey a sense of distance by making an artificial haze. Move the center arrow to the left, turning the background a light gray. After exiting the Levels dialog, press [Command-D] [Windows: Ctrl-D] to remove the selection, and repeat step 4.

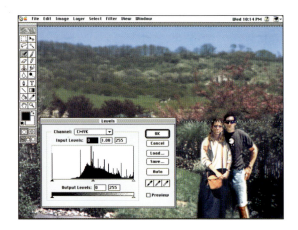

Selective exposure control: burning and dodging

6 The Dodge and Burn tools, like their darkroom namesakes, allow for lightening and darkening specific areas. Here the Burn tool is used to enhance the continuity of lighting by darkening the left side of the faces and certain spots in the foreground.

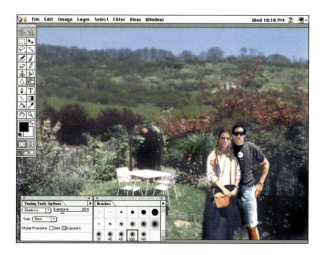

Sharpening with Unsharp Mask

7 Once again, repeat step 2 to create a gradient, but this time make it from the top to the bottom. Apply the Unsharp Mask filter, with the amount set to 50 percent, a radius of 1.0 pixel, and a threshold of 0. The results of this operation will vary depending on the picture but the desired effect is for the foreground to stand out against the background. Press [Command-D] [Windows: Ctrl-D] and save the changes.

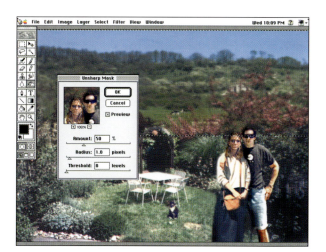

Using Unsharp Mask

Unsharp masking, a term carried over from a bygone technology, will not sharpen a very blurry picture. It will, however, give fine control over the *perceived* sharpness of a normal one.

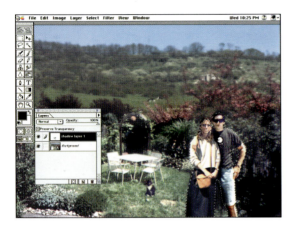

Making a shadow

8 Begin by selecting the people (see Chapter 5). Then press [Command-J] [Windows: Ctrl-J], creating a layer, and name it "shadow 1." In the Layers palette, duplicate this layer and name the new layer "shadow 2." Note: Close attention should be given to the existing shadows in the base picture. Their direction and harshness are relevant to the following steps.

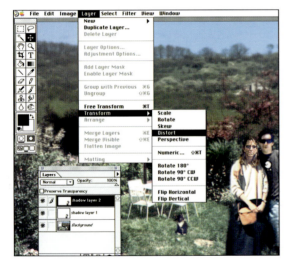

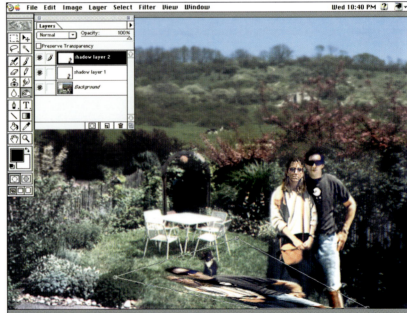

Putting the shadow in perspective

9 With "shadow 2" selected in the Layers palette, choose the Transform, Distort command. Following the lead of the shadows in the base picture, move the distorted image in the same direction.

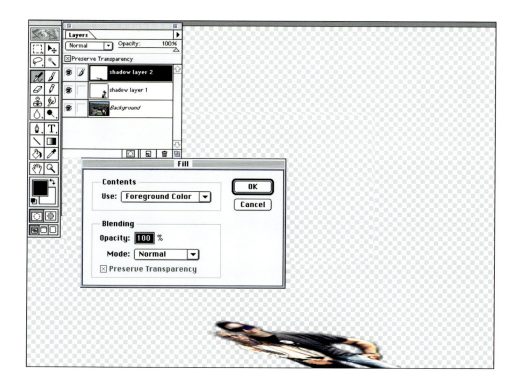

Shading the shadow

10 Option-click "shadow 2" on the Layers palette, leaving just that layer displayed. Click on Preserve Transparency and choose the Fill command to fill the non-transparent portions of the layer with black at 100 percent with the Darken mode selected. Click Preserve Transparency off and make a marquee around "shadow 2." Apply the Gaussian blur filter to the selection to match the look of existing shadows. Harsh shadows require a radius of about 4 pixels; use 8 or more for softer ones.

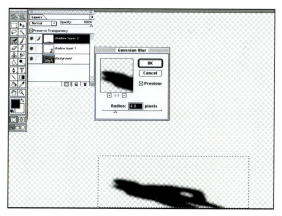

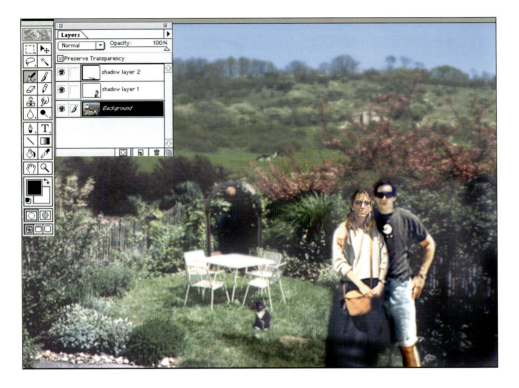

Fixing a shadow

11 Option-click "shadow 2" to reveal both the new shadow and the other layers. Noting the darkness of the shadow under the table, set the transparency of the "shadow 2" layer to about 50 percent (using the Layers palette). Move "shadow 2" beneath "shadow 1" on the Layers palette to place the shadow behind the people. Merge the layers and save changes in RGB mode. Steps 8, 9, 10, and 11 were repeated for the cat.

Mechanically made postcards

Using the procedure from Chapter 4, a postcard mock-up can be made by hand. An airbrush (Chapter 8) will add haze to the background, and the result can be rephotographed (Chapter 2) for printing on postcard-sized paper.

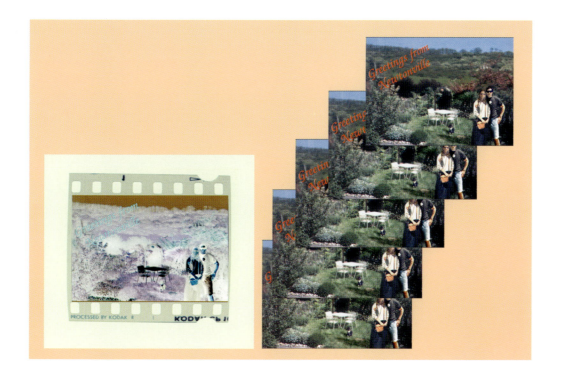

Postcard production

12 Take the 300-dpi, RGB file (in its positive form—don't invert the image) to a service bureau with a film recorder and request a 4k 35mm negative on print, not transparency, film. The resulting negative can be used to make inexpensive reprints at a conventional photo lab. See page 68 for the final results.

Other Techniques Used in This Chapter

• Creating a digital mock-up

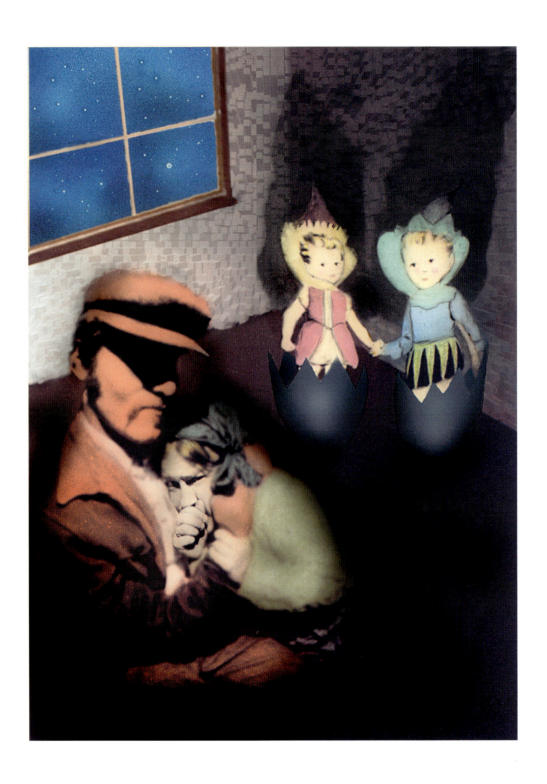

Working with an Airbrush

Project

Fabricating a poster for a fictional campy horror film, in the process demonstrating airbrush techniques. A digital mock-up was made with a base picture and three picture elements. The poster-illustration was output as a black and white dye-sublimation print, hand-colored, and airbrushed, with digitally applied text.

Airbrushes are tricky little machines that can be used simply or with complex friskets (masks) to create realistic renderings. They link cave paintings (made by chewing pigment and spitting it onto the walls, using a hand as a mask) with the Airbrush tool and masking features used in digital imaging today. The appeal of an airbrush lies not just in its unique properties as an artistic tool, but in its stick-shift-in-the-hand mechanical feel. Like hand-coloring, airbrushing gives artists a unique physical connection to their work.

This picture was designed as a promotional piece for a fictional horror film called *The Hatchlings*, in which pixie-like creatures arise from their eggs to terrorize the population. The mock-up was made digitally and output as a black-and-white print. The color was applied by hand using oils and pencils. Airbrushing was used to give the eggs and sky a quality that would complement the bizarre nature of this picture.

At left is the picture before being rescanned and having the text added. The final result is shown on page 87.

Materials and Tools

- Airbrush

- Airbrush paints (designed for working on paper)

- A compressor (small cans of air get very expensive)

- Face mask (with filters designed for airborne paint) and safety goggles (both are optional but important to use)

- Portable air cleaner (also optional—need not be very large or expensive unless extensive airbrushing is being done)

- Photographic oils and pencils

- Low-tack frisket paper

- Tracing paper

- Craft knife

Getting on track

1 Airbrushes are like race cars: fun and sleek-looking, but requiring consistent maintenance and firm handling. In the long run, an air compressor with a holding tank is the best source for a propellant— they're more economical than cans of air and quieter than a small compressor that runs continuously. Note: Safety equipment—face mask, goggles, air cleaner—is optional but strongly suggested. Some tube paints that are non-toxic in solid form become toxic when aerated.

2 A mock-up is assembled digitally and output as a black-and-white file on a dye-sublimation printer. The print is sprayed with matte spray and hand-colored. The use of an airbrush and the addition of text were anticipated in planning the mock-up.

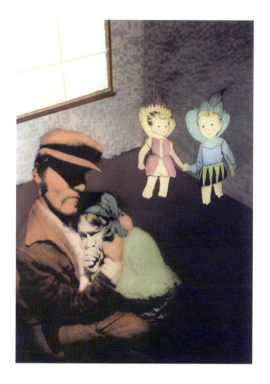

Setting it up

3 First tape the mock-up to a piece of mat board, then tape a sheet of tracing paper over that. Make a small "X" on each corner of the mock-up and each corresponding corner of the tracing paper—these will act as registration marks if the two are separated. In this demonstration, the "Hatchlings" will appear to emerge from eggshells. Draw an outline of the eggs on the tracing paper to create a guide for cutting the frisket (mask) conforming to where the eggs will be airbrushed on the mock-up.

4 Lift the tracing paper and apply a piece of low-tack frisket material—slightly larger than the area being airbrushed—to the mock-up. Replace the tracing paper and use a craft knife to cut through the tracing paper and the frisket material beneath it, following the drawing. Note: The goal is to cut out the frisket material without damaging the print. The tracing paper and frisket material are very thin and require very little knife pressure. Optionally, the frisket can be cut freehand without using tracing paper as a guide.

Use precision when airbrushing

Airbrushes require a deft touch and a little coordination. Pressing down on the trigger releases the air, and pulling it back releases the paint; balancing the two is tricky. The distance of the nozzle from the surface varies the thickness and density of lines. The task can be summed up in three words: practice, practice, practice.

Airbrushing a shaded egg

5 Lift the tracing paper and, using the knife point, gently remove the egg section of the frisket that was just cut. Replace the tracing paper and cut out a section larger then the eggs, taping the tracing paper frame to the frisket material to prevent overspray on the print. Note: Frisket material can be used to cover the whole print, but a small piece is easier to remove—and potentially less damaging. Move the airbrush in steady strokes across the opening, overlapping the frisket and pausing between strokes to allow the paint to dry. When the area is a flat opaque color, use black paint in light strokes to add shading to the edges of the eggs. Finally, use white paint to add a soft highlight to the center of each egg. Go slow and easy.

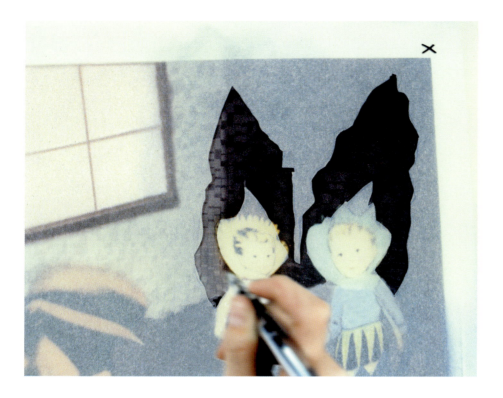

Airbrushing a soft shadow

6 Repeat step 3 to make a shadow behind the Hatchlings. This time only tracing paper will be used as a frisket. Note: Self-sticking frisket material, such as the type used in step 5, will produce a hard edge; tracing paper alone will result in a soft edge.

7 With the friskets removed, the eggs and shadows are revealed. In skilled hands airbrushes can produce either smooth gradients or a flat tone; in conjunction with elaborate friskets, virtually any design can be achieved.

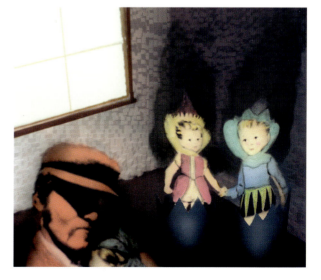

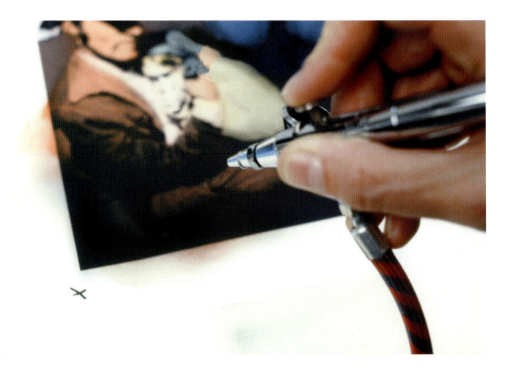

Working freehand

8 An airbrush can be used freehand to add shading or smooth the transition between picture elements. Light strokes of black paint can add depth or the look of natural light falling on an object.

Hiding cut marks

An airbrush can be used to hide cut marks in a mechanical mock-up or smooth the transition between picture elements in a digital one, by darkening obvious transitions with black paint. When a mechanical mock-up is re-photographed, it picks up contrast, causing details to drop out in the darkest areas, thus hiding the cut marks. If the mock-up is being scanned, the same effect can be achieved by using Photoshop's Levels command to add contrast.

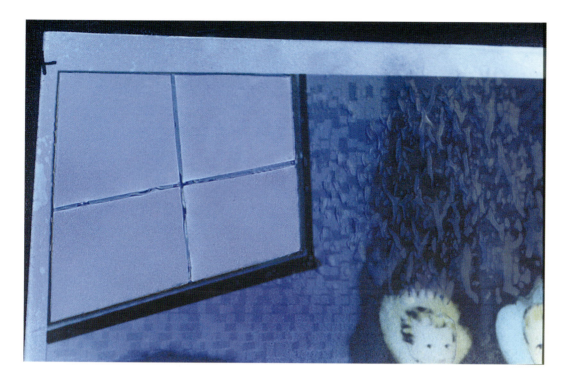

Airbrushing a twilight sky

9 Apply a piece of low-tack frisket material that extends just beyond the window area, and cut out the window section. Lay a paper mask over the portion of the print that is still exposed, then tape it to the frisket material to protect the print. First spray a flat layer of medium blue paint over the whole window. Then, to add soft highlights, hold a small piece of cotton over the window with tweezers and move it around while spraying a light coat of white paint.

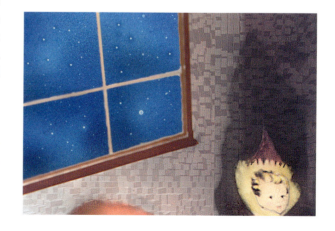

10 The stars are done by reducing the air pressure on the compressor and spraying white paint, causing a stippling effect. Finally, dark areas are added by using the airbrush freehand with black paint. When the sky is completed, carefully remove the frisket material.

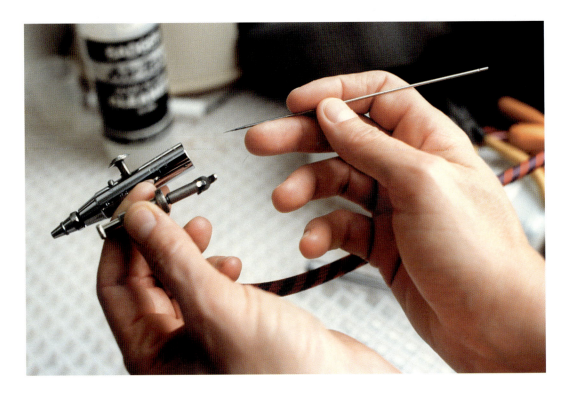

Cleanliness prevents stickiness

11 Clean the airbrush after each use to prevent old paint from clogging up the internal parts. Despite differences in design, all airbrushes are built for easy disassembly and cleaning.

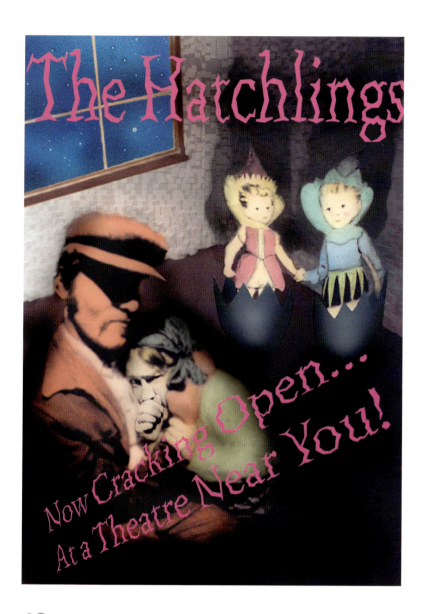

12 At the pre-press stage the mock-up is scanned into a computer (this can be done by a service bureau). The titles are added in Photoshop using the Text tool and the picture is saved as an EPS file prior to sending it out to a printer for color separations.

Other Techniques Used in This Chapter

- Acquiring pictures digitally
- Creating a digital mock-up
- Outputting to paper
- Hand-coloring

PART 1

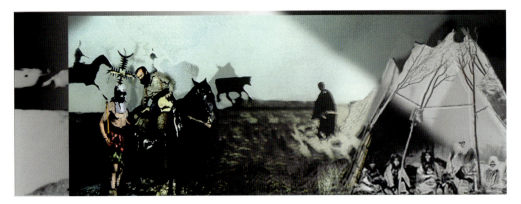

PART 2

Outputting to Film

Project

Making artwork that blends mechanical and digital methods, in the process demonstrating techniques of outputting to film. In Part 1, a negative from an imagesetter is used to show how a mechanical print can be made from a digital source by contact-printing it on photographic paper. In Part 2, a digital image is first output to a 35mm black and white negative which is printed, re-scanned, and then re-output as a 4"x 5" (10 cm x 13 cm) transparency for final printing.

For many artists their love affair with photography is not about cameras, but the look of the photographic print. By outputting artwork to film, the "digiographer" can pair up the flexibility of computer graphics with conventional photographic printing materials. Additionally, it's currently less expensive and easier to make multiple prints using a negative and photographic paper than to produce multiple copies digitally. Even as the quality gap narrows between digital and silver-based materials, there will always be artists who choose to make their own prints—because darkroom printing is a labor of love.

Part 1's illustration is from a series of prints called *A View From the Back of the Bus*. It addresses issues of civil rights and conflicting social messages. Part 2 shows an image from a series titled *Dioramas of the Old West: Indians, Settlers, and Katcinas*. This series pays homage to the Hopi Indians' culture of the Katcina. The work in both series uses photomontage to confront complex issues through visual metaphors.

The illustrations at left show the transition of materials discussed in this chapter. The final pieces appear after each section.

Materials and Tools

- A computer system: minimum 32MB RAM, 100MB free hard drive space

- Adobe Photoshop: available for Macintosh, Windows, or UNIX machines

- Scanner (scans can be ordered from a service bureau)

- Imagesetter negatives (can be ordered from a service bureau)

- Darkroom with enlarging equipment

- Contact proofer or sheet of glass

PART 1: Outputting to an imagesetter

Preparing your file

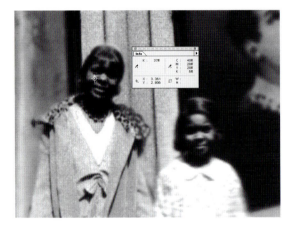

1 Prior to outputting a file, enlarge the picture on the monitor and use Photoshop's Info palette to check the contrast. Choose Options from the Info palettes menu and set one of the readouts to grayscale. Move the cursor (the Eyedropper provides an easy-to-use crosshairs) over the highlight areas first, looking for readings lower than 5 percent; details in these areas will be washed out. Now move the crosshairs over the darkest areas; readings higher than 95 percent will result in a loss of shadow detail. Use the Levels command to correct as necessary, then save as an EPS file.

2 A graphics file can be transferred to a service bureau by modem or in parts using floppy disks. However, the most common medium is removable hard drives. There are several brands, and they're always getting bigger and faster, so check with the local service bureau for compatibility before investing.

The alternative negative

3 Imagesetters produce negatives with varying halftone screens designed for lithographic printing. However, these can be mechanically contact-printed with excellent results—thus offering the artist a choice of papers unavailable with dye-sublimation printers. A black-and-white file output at 2,400 dpi with a 200-lpi screen produces a negative that can be contact-printed with very good results. Negatives made this way have less contrast than continuous-tone negatives produced digitally, and they don't require an enlarger to print. Note: Think ahead; since this negative will be contact-printed, make sure the file you output corresponds to the print size desired.

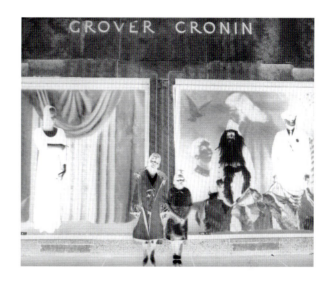

The two-for-one rule

When outputting to an imagesetter, best results will be achieved by printing at 150 to 200 lines per inch. The resolution of the file being output should be twice the lpi in dots per inch; for example, a 300-dpi file can be printed with a 150-lpi screen.

4 Raise the enlarger until the light spills over the whole negative and close the lens down about two stops. Place the imagesetter negative on a sheet of photographic paper, then lay a piece of glass over it to hold it flat. Do a test strip to determine the exposure time.

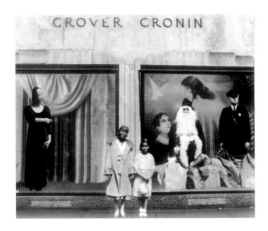

5 Process the print just like any other black-and-white print. If you plan to hand-color the print make it on matte paper; otherwise it will have to be sprayed first.

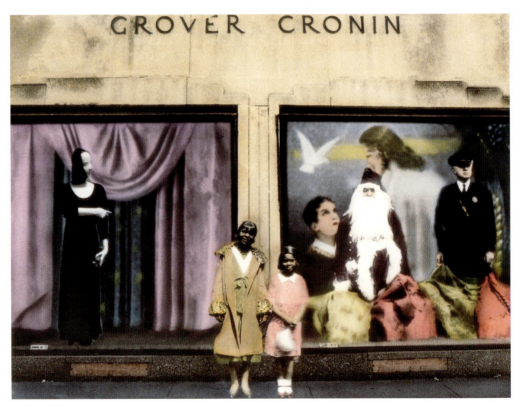

6 After being printed, the picture was hand-colored using oils, pencils, and an airbrush, then re-photographed with transparency film. This permits the final image to be reprinted as necessary.

PART 2: Outputting to a negative or transparency

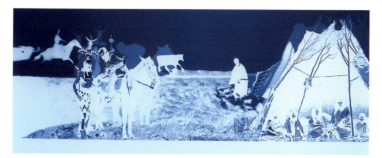

7 Save a positive black-and-white file picture as a grayscale file, to be output from a film recorder. This file was output on 35mm film at 4K. Note: Be sure to request that the negative be output on black-and-white, not color transparency film; this will result in a negative as shown above.

Converting digital to analog

Film recorders (shown) contain a camera with regular film that photographs a high-resolution monitor, converting the digital file into analog form.

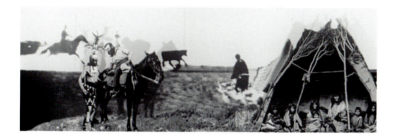

8 Enlarge the new negative on standard photographic printing paper. As in step 3, use a matte paper so the print can be hand-colored without being sprayed first. Since this picture is going to be rescanned, make the print just big enough to work on; making it too big will make the rescanned color file large and slow to work with. This image is printed at 8" x 20" (20 cm x 51 cm) because of its elongated format.

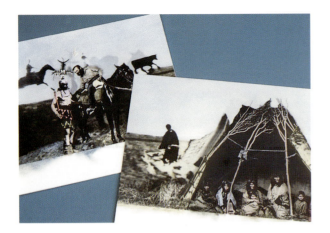

9 This print is hand-colored using a variety of methods. First the whole print is toned brown, then it's hand-colored using oils and pencils. Following that, a craft knife is used to cut the picture in half, allowing the print to be scanned in two pieces to produce two small files instead of one large one. The two halves (named "side 1" and "side 2") are scanned as a 300-dpi RGB file. After the picture is digitized, additional manipulations are performed on each half.

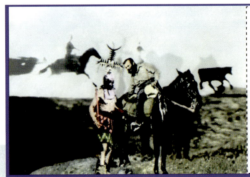

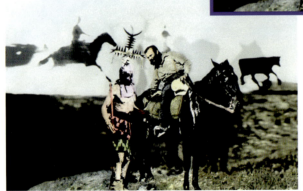

10 Open "side 1" (the left side of the image) in Photoshop and choose the Canvas Size command. Click on the left center box in the Anchor grid and enter a width that is double the present width. After the image "canvas" has been resized, open "side 2" (the right side of the picture) and press [Command-A] [Windows: Ctrl-A] and then [Command-C] [Windows: Ctrl-C]. Go back to "side 1" and click in the white half with the Magic Wand tool. Choose the Paste Into command to place "side 2" in the white area, uniting the two halves, and adjust the right side of the image until it's perfectly aligned. Note: Pressing [Command-H] [Windows: Ctrl-H] will hide the marquee's "marching ants," making it easier to see where the two sides meet. Press [Command-D] [Windows: Ctrl-D] to deselect the right side, and Save As to create a new file containing the whole image.

The importance of planning

11 An 8" x 10" (20 cm x 25 cm) file at 300 dpi will produce a good quality 4" x 5" (10 cm x 13 cm) 8K transparency that will be fine for all but the most critical work. Because of the format of the images in this series, two files can be placed on each sheet of film, saving service bureau costs.

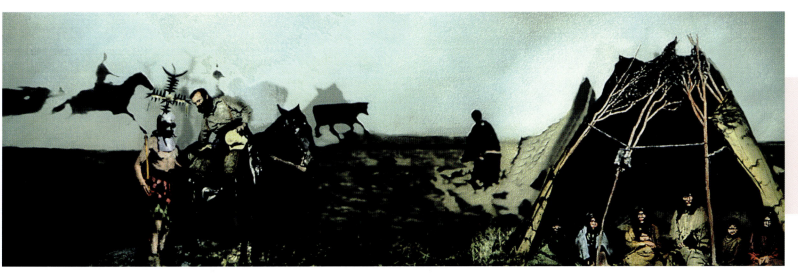

12 The final transparency is printed on Ilfachrome material at 8 1/2" x 22" (21 cm x 56 cm). The advantages of this method are repeatability, the beauty of photographic materials, and work that lacks the thumbprint of any single process.

Other Techniques Used in This Chapter

- Creating a digital mock-up
- Hand-coloring
- Airbrushing
- Digital retouching
- Acquiring pictures digitally

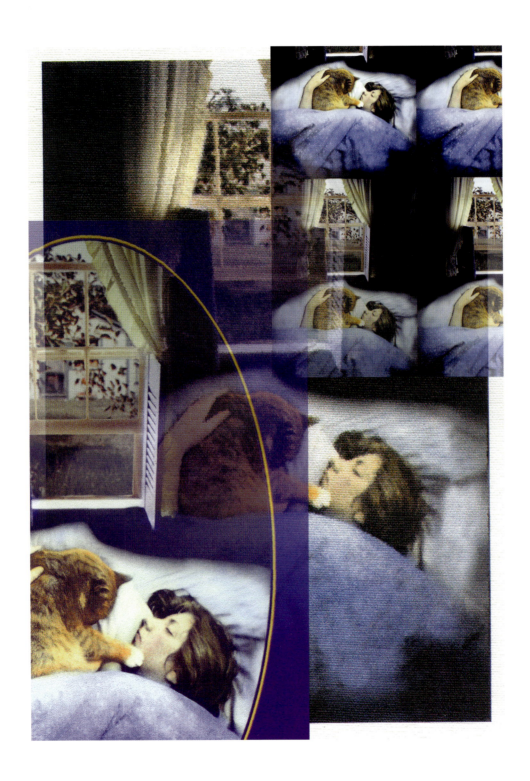

Outputting to Paper and Fabric

Project

Producing a unique portrait package that includes wallet size and two 8"x10" pictures, in the process demonstrating techniques of three digital printing options. The output materials—canvas, dye-sublimation paper, and watercolor paper—were specifically chosen to complement three versions of the portrait.

Taking mechanically created images and printing them digitally offers artists, or their clients, new forms of the fixed image. The relative ease and diversity of printing options provide many compelling reasons for taking this route. This area of technology is in an upward spiral, with the aesthetic gap between traditional printing methods and what had been the weak link in the digital chain constantly narrowing. As this technology develops, it's establishing a separate, but equal, aesthetic standard of its own.

Portraiture has been a staple of artistic expression for thousands of years. Technologies will change, but the goals of portraiture will remain the same. Whether the intention is to make a flattering rendering, divulge keen insights, or offer a new view of someone familiar, as long as there are people, artists will seek creative ways to illustrate them. In this demonstration, a conventional photographic portrait was hand-colored, basically as it was done one hundred years ago. The twist was digitally montaging it and printing it on machines that didn't exist just a few years ago.

This illustration sums up the contents of the portrait package demonstration.

Materials and Tools

- Computer system: minimum 32MB RAM, 100MB free hard drive space

- Adobe Photoshop: available for Macintosh, Windows, or UNIX machines

- Scanner (scans can be ordered from a service bureau)

- Printers capable of printing on canvas and watercolor paper (available at larger service bureaus)

- Dye-sublimation printer (available at most service bureaus)

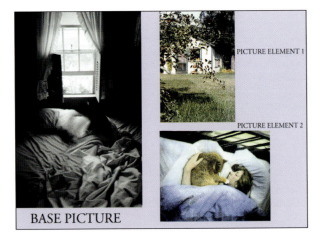

PICTURE ELEMENT 1

PICTURE ELEMENT 2

BASE PICTURE

An imaginary portrait

1 Forget natural light and other portrait conventions; take a picture of a subject, combine it with other picture elements, and place them in a base picture to form a personalized portrait. For this illustration, pictures that were meaningful to the subject shown in Picture Element 2—a vacation spot and former residence—were combined.

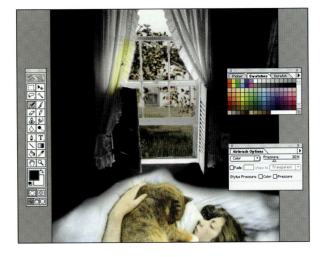

Hand-coloring...digitally

2 Using the Airbrush tool is an effective means for coloring small areas. Select a color from the Color or Swatches palette. Select the Airbrush from the toolbox, choose Color from the mode pop-up menu on the Airbrush Options palette, and set the opacity to 30 percent (much higher will be too opaque). Spray the color in the chosen area, then adjust using the Saturate/Desaturate tool and the Burn and Dodge tools. Note: This technique lacks the "personality" of actual hand-coloring.

3 After completing the image, save this file as "Basic portrait." Printing this picture as is would make an interesting portrait—but that would be an ordinary presentation of an extraordinary image.

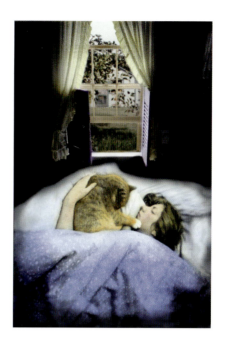

Wallet-sized prints

4 Resize the file "Basic portrait" picture to 3 1/2" x 5" (9 cm x 13 cm) using the Image size command, then Save As (don't just Save) with the name "Wallet-sized picture." Press [Command-A] [Windows: Ctrl-A] to select the picture and open a new file that is 7" x 10" (18 cm x 25 cm). Now drag "Wallet-sized picture" into the new file to make a new layer. Click the Duplicate Layer button on the Layers palette three times, until there are four images on the page. Move the pictures so they sit border-to-border on the page, and Save As with the name "Wallet-sized pictures" in EPS format.

Watercolor print

5 Reopen the file "Basic portrait" and Save As (don't Save) "Watercolor picture." The object is to modify the image, making it complementary with the look and texture of watercolor paper. Make an oval selection marquee around the center of the image.

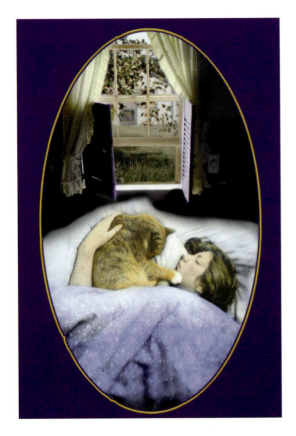

6 Reverse the selection with the Invert command ([Shift-Command-I] or [Windows: Shift-Ctrl-I]). Choose a foreground color (blue is used here) and press Option-Delete to fill the selection. Invert the selection again and go to Select, Modify, Expand—set the dialog box to 10 pixels and click OK. Select a color (gold is used here) from the Color palette and use the Edit, Stroke command, set to 5 pixels, to add a border. Save As "Watercolor print" in EPS format.

Consider the source

When outputting to an unconventional medium such as watercolor paper or canvas, consider whether the image will look appropriate on that material. Mismatching the image and output medium will distract from an otherwise interesting picture.

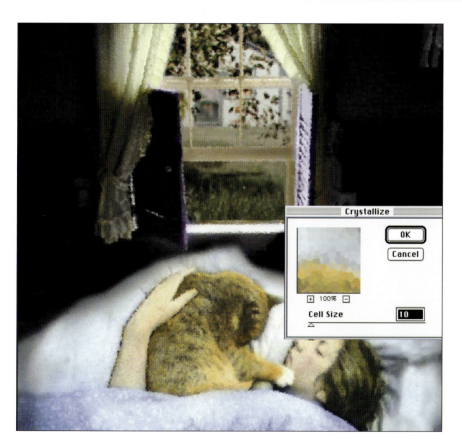

Canvas print

7 Open "Basic portrait" and use Save As to make a new file called "Canvas print." Apply the Crystallize filter with a Cell Size of 10 to make the image look suitable for printing on canvas. As with any effect or technique, don't overdo it or the significance of the original image will be obscured. When the filter has been applied, save the file.

8 The facilities available at service bureaus vary widely. In general, they offer scanning and printing, but within those categories there are big differences in quality, output sizes, and features. The machine shown here is an inkjet printer capable of outputting from small to mural size on a variety of materials, including canvas (top). The canvas print in step 12 was made on this machine.

9 Most digital images are output on machines like these. At left is an inkjet printer that will accept a variety of papers—the watercolor print in step 11 was printed on this machine. To the right is the ubiquitous dye-sublimation printer, capable of high-quality black-and-white or color prints. The wallet pictures in step 10 were printed on this machine.

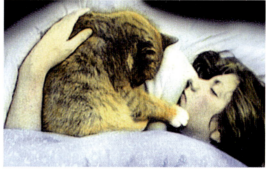

Dye-sublimation prints

10 On a single sheet of paper, output the file "Wallet-sized pictures" from a dye-sublimation printer. Cut the sheet up into individual wallet-sized prints. Note in the detail the excellent color and fidelity of a dye-sublimation print. When printing a very high-resolution file, these machines rival the best results traditionally achieved by printing film on photographic paper.

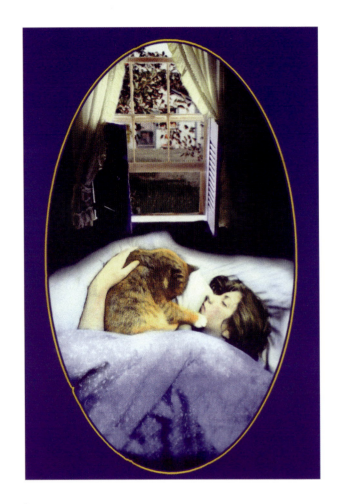

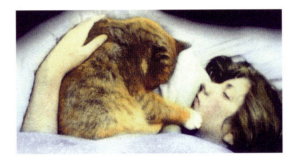

Watercolor paper prints

11 Next, using watercolor paper in an inkjet printer, print the file "Watercolor print." Variables in watercolor paper such as thickness, texture, and absorbency may cause slight color changes. The obvious texture and rich color, seen in the detail, are part of the charm printing on watercolor paper offers.

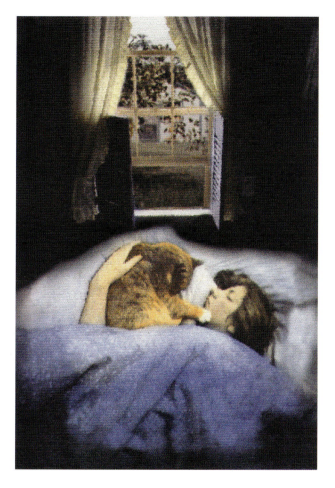

Canvas material prints

12 Finally, output the file "Canvas picture" on canvas material from an inkjet printer designed for this task. Though this print was made at 8" x 10" (20 cm x 25 cm), depending on the size of the file (there must be enough information to enlarge it), these machines can print up to 48" (122 cm). Note: Because details are less obvious on canvas material (as opposed to dye-sub prints), this print could have been made 48" x 48" (122 cm x 122 cm) with little image degradation (resolutions as low as 72 dpi will suffice for less critical work). The detail shows how the canvas material and the manipulation applied in step 7 work together to make an unconventional portrait.

Other Techniques Used in This Chapter

- Acquiring pictures digitally
- Hand-coloring
- Creating a digital mock-up
- Digital retouching

Gallery

The information in this book was intended to provide artists with a starting point for working in photomontage. It should be clearly understood that the examples given in the previous chapters represent just one application of each process—not a set of rules. Think about a base picture made from not one, but fifty pieces. Try cutting a single picture element into ten pieces or repeating it ten times. Paint or draw on a digitally produced watercolor or canvas print. Instead of pre-planning the mock-up, as the book suggests, work spontaneously, allowing the artwork to emerge from the materials. The following portfolio demonstrates the inherent diversity of photomontage, showing its potential as a boundless art form.

The artists in the gallery were chosen not just for their imagery, but for their ingenious methods of blending picture elements into a greater whole. Though the emphasis in this book is on combining digital and mechanical methods, generally most artists work in one or the other, with a growing number using both. The gallery represents all of those groups. The artists who create their work mechanically are Audrey Bernstein, Maryjean Viano Crowe, Robert Hirsch, William Larson, Bart Parker, Vaughn Sills, Esther Solondz, and Jane Tuckerman. The ones working digitally are Richard Rosenblum, Osamu James Nakagawa, Martina Lopez, Olivia Parker, Leslie Starobin, and Anna Ullrich. While most of the artists working mechanically use more than one medium—perhaps because of the complexity or diversity of the process—the digitally based artists tend to stay within that realm. As happened with photography, the lines between the knife and keyboard will blur as more people become comfortable with the technology.

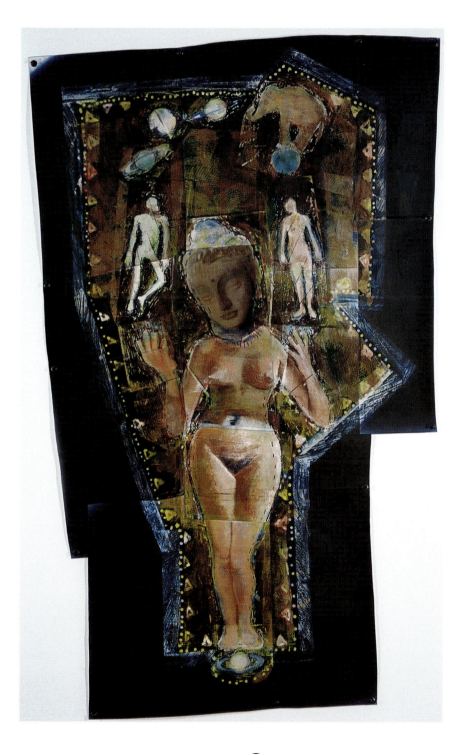

It's interesting that most of the artists in the gallery began by making conventional point-the-camera-and-record-the-scene photographs. For many people working in traditional photography, the photograph is sacrosanct—they believe that to change it is to play with the truth. In fact, traditional photography uses manipulation in the form of burning, dodging, and cropping. Is moving or adding elements within the framework of a picture really very different from choosing what portion of a scene to include in a picture? The artists in this book have discovered, as many others have, that photomontage borrows on photography's truthful reputation—but without the pretense of making an historical document. Additionally, it offers them an instrument capable of making the picture they want, rather than simply recording what they find. To quote Bart Parker, "photomontage is more interesting to execute, more demanding: jazz instead of golden oldies." Each of these artists, whether working with glue or a computer, elevates the basic premise of photomontage—cut and paste— to the level of language: understandable, didactic, and moving.

Maryjean Viano Crowe
Project *Le Cirque Eternal* (one of a series)
Rendering size 80" x 48" (204 cm x 122 cm)

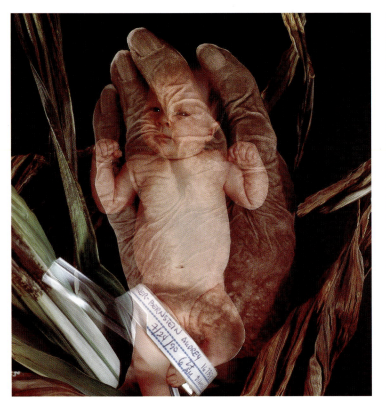

Project *Isabel Anna*
Rendering size 15" x 15" (38 cm x 38 cm)

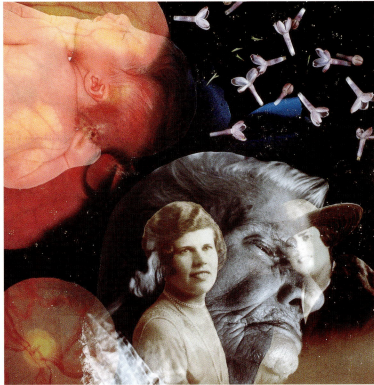

Project *Bloodline*
Rendering size 15" x 15" (38 cm x 38 cm)

Audrey Bernstein

Bernstein's work seems to reflect on conflicts and questions: Who will be there? Where did the time go? Symbols of life, birth, and death battle for common ground in her photographic dramas. Bernstein finds photomontage challenging because it allows her to "juxtapose images in an unconventional fashion and create an illusory world." By combining images she is able to "intermingle incongruous material," putting the focus on the "images and their relationships rather than the techniques employed." Amazingly, Bernstein creates this work with a camera, using multiple exposures. Using a twin-lens reflex camera, she pre-plans and composes her pictures by putting masks in the viewfinder. Bernstein's work informs viewers that "familiar objects, personal memories, and myths" are symbols of "intimate truths."

Project *And She Was Esther*
Rendering size 15" x 15" (38 cm x 38 cm)

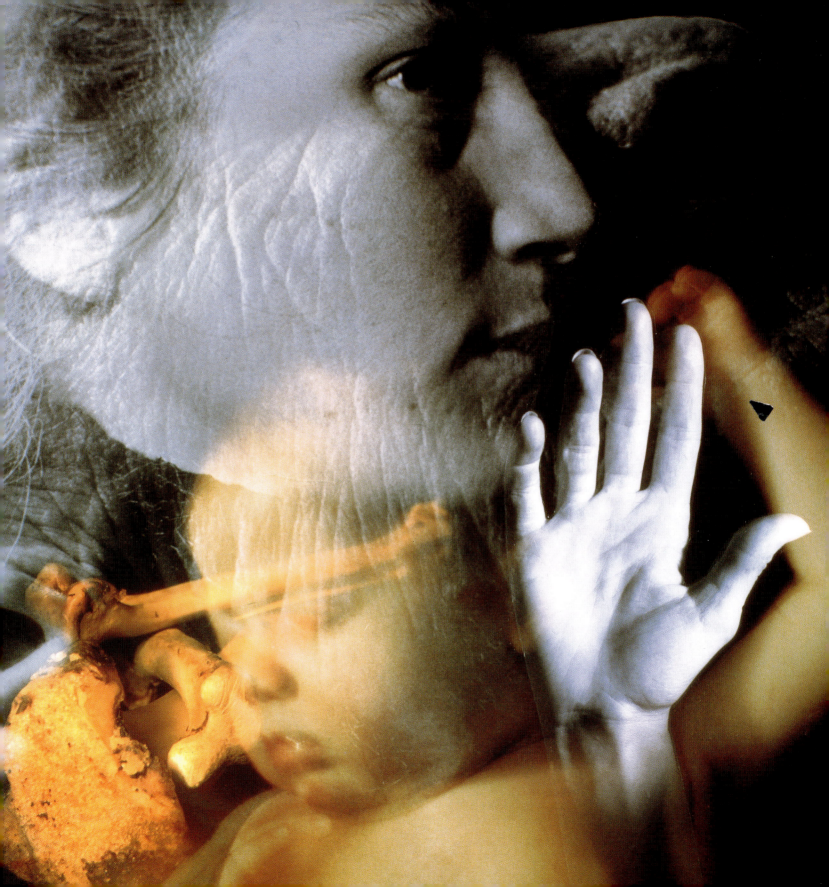

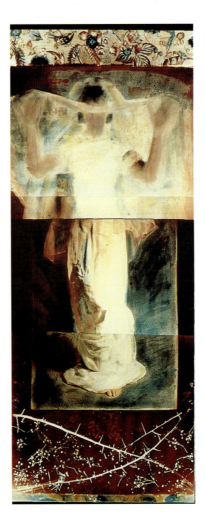

Project *Daughters of Mystery: The Unveiling*
(one of a series)
Rendering size 28" x 67" (71 cm x 171 cm)

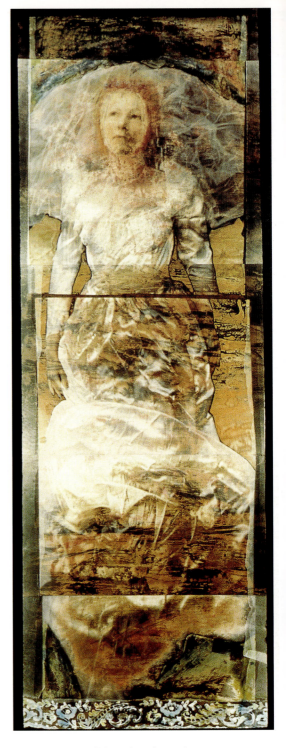

Maryjean Viano Crowe

An effusive blend of emotion and intellect, Viano Crowe's work overwhelms with powerful images that chant in soft colors and whispered feelings. Religious overtones give this work a feeling of sanctity, bathing the viewer in a quiet peace. With a "maximalist" philosophy—believing that "more is more"—Viano Crowe paints and tones large-scale photographs from "elaborate" negatives. The varied picture elements are taped together in superimposed layers, resulting in a blended but complicated whole. Viano Crowe sees herself as an inventor, "assembling detritus from my own and other worlds, juggling the past with the present . . . Within this melange, personal history, popular culture and art historical references collide." In the series "Daughters of Mystery," Viano Crowe looks inward at pain, family, and loss.

Project *Daughters of Mystery* (one of a series)
Rendering size 28" x 80" (71 cm x 204 cm)

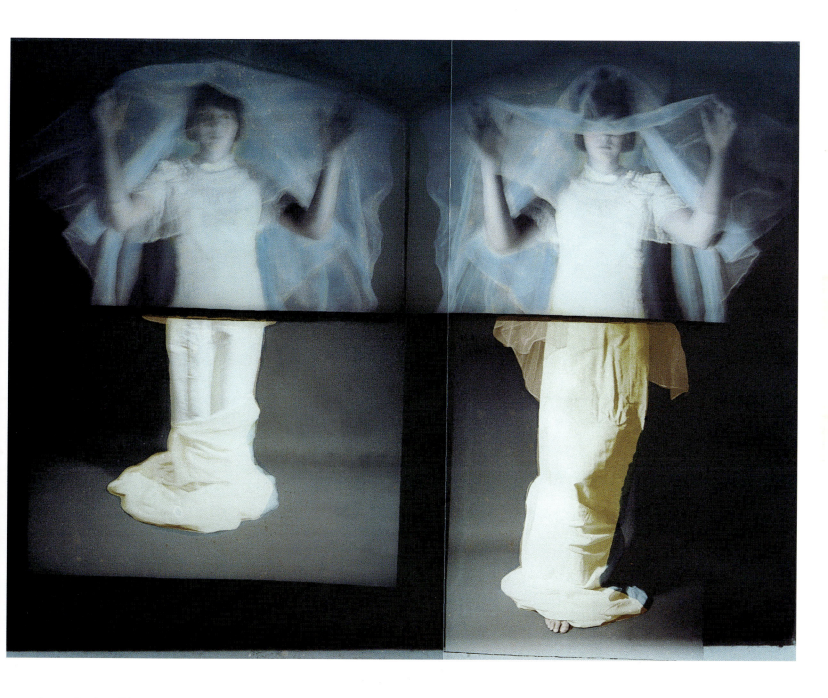

Project *Daughters of Mystery* (one of a series)
Rendering size 28" x 39" (71 cm x 99 cm)

Stephen Golding

These images confront the pathology of racism—invoking the power of metaphor to plead their case. Working on several levels, they pose the question, "What does hatred look like to the hated?" Photomontage permits the creative freedom of painting with the unique properties of the photographic image. These pictures were scanned into a computer, recomposed, and output to film. After photographic prints were made, color was applied with oils, pencils, and an airbrush and the images were rescanned and output to a 4" x 5" (10 cm x 13 cm) transparency for reprinting. The resulting work has a unique aesthetic quality achieved by combining the techniques outlined in this book. These pictures ponder aberrant behavior—in particular, the extremes of hatred and violence people are capable of—because it is perplexing, fascinating, and deeply disturbing.

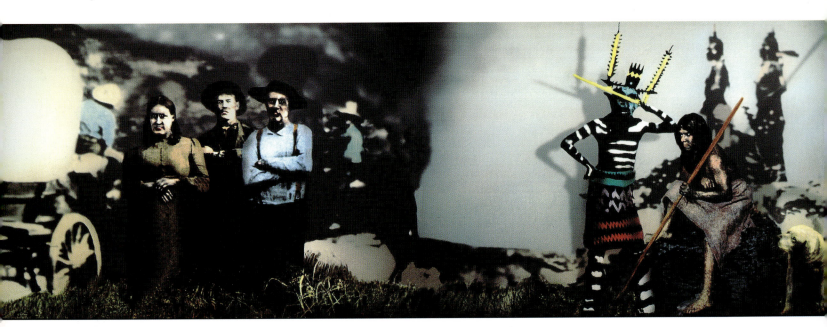

Project *Dioramas of the Old West: Indians, Settlers, and Katcinas* (one of a series)
Rendering size 8" x 23 1/2" (20 cm x 60 cm)

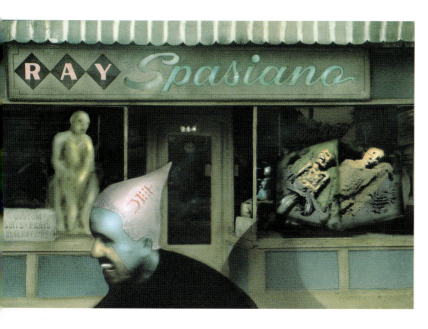

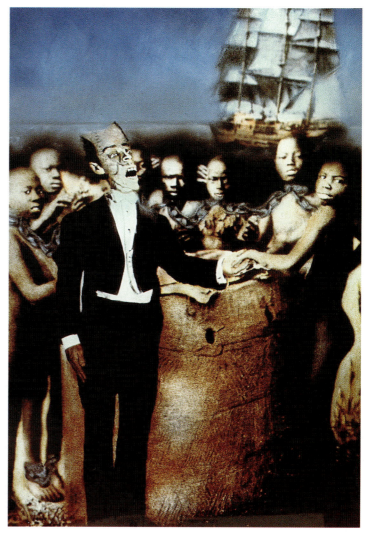

Project *Road to Necropolis*
(one of a series)
Rendering size 20" x 24" (51 cm x 61 cm)

Project *A View From the Back of the Bus*
(one of a series)
Rendering size 20" x 24" (51 cm x 61 cm)

Project *In Trouble Again*
Rendering size 16" x 20" (41 cm x 51 cm)

Robert Hirsch

With a sense of fun and symbolism, Hirsch weaves pictures that welcome the viewer. Icons and graphics grapple for space in these complex compositions, tickling and challenging the viewer to enjoy the ride. For Hirsch photomontage is a "composite approach of photography, drawing, painting, and words," allowing him "the freedom for non-linear thinking and feeling." His pictures offer not just one point of view, "but many views that dynamically overlap, complement and even contradict each other." Hirsch uses varied mechanical methods for creating his work, including, but not restricted to, multiple printing, masking techniques, airbrushing, and paint. In this body of work "contemporary American dilemmas such as alienation, the lack of permanent icons, and how everything is for sale" are explored.

Project *Men Who Would be Good*
Rendering size 16" x 20" (41 cm x 51 cm)

Project *Running to the Craters of the Moon*
Rendering size 16" x 20" (41 cm x 51 cm)

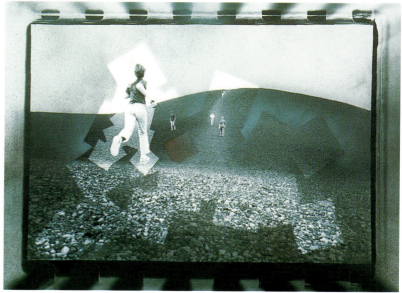

Project *Theater du Monde* (one of a series)
Rendering size 24" x 38" (61 cm x 97 cm)

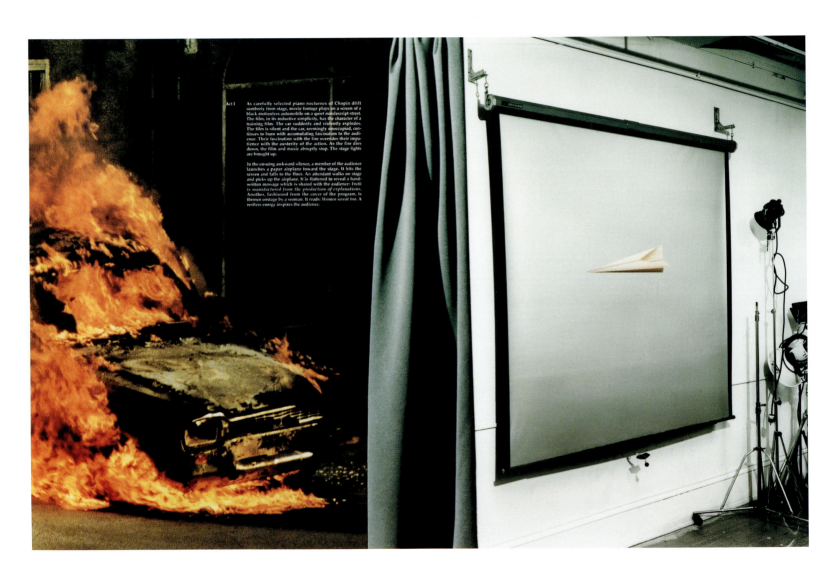

Act I As carefully selected piano nocturnes of Chopin drift somberly from stage, movie footage plays on a screen of a black motionless automobile on a quiet nondescript street. The film, in its reductive simplicity, has the character of a training film. The car suddenly and violently explodes. The film is silent and the car, seemingly unoccupied, continues to burn with accumulating fascination to the audience. Their fascination with the fire overrides their impatience with the austerity of the action. As the fire dies down, the film and music abruptly stop. The stage lights are brought up.

In the ensuing awkward silence, a member of the audience launches a paper airplane toward the stage. It hits the screen and falls to the floor. An attendant walks on stage and picks up the airplane. It is flattened to reveal a handwritten message which is shared with the audience: *Truth is manufactured from the production of explanations.* Another, fashioned from the cover of the program, is thrown onstage by a woman. It reads: *Women sweat too.* A restless energy inspires the audience.

Project *Theater du Monde* (one of a series)
Rendering size 23" x 38" (58 cm x 97 cm)

Project *Theater du Monde* (one of a series)
Rendering size 30" x 38" (76 cm x 97 cm)

William Larson

In the theater of Larson the viewers become the players, reciting their lines without fear of stage fright. The viewer/player wonders: Is this the view of the stage—or the view from the stage? Larson feels that photographs are a "kind of quote, and collaging them is a means of having them converse around a particular objective or class of objectives." He adds, "Their potential together resides not in how they are offered, but in how they are read." With deceptively simple mechanical methods, Larson cuts and pastes his picture elements, which allows him "a physical and conceptual relationship to the work." It's a "slow, protractive process" with careful attention to the "compatibilities and continuities needed in creating a seamless imaginative space."

Project *Revolutions in Time*
Rendering size 30" x 50" (76 cm x 127 cm)

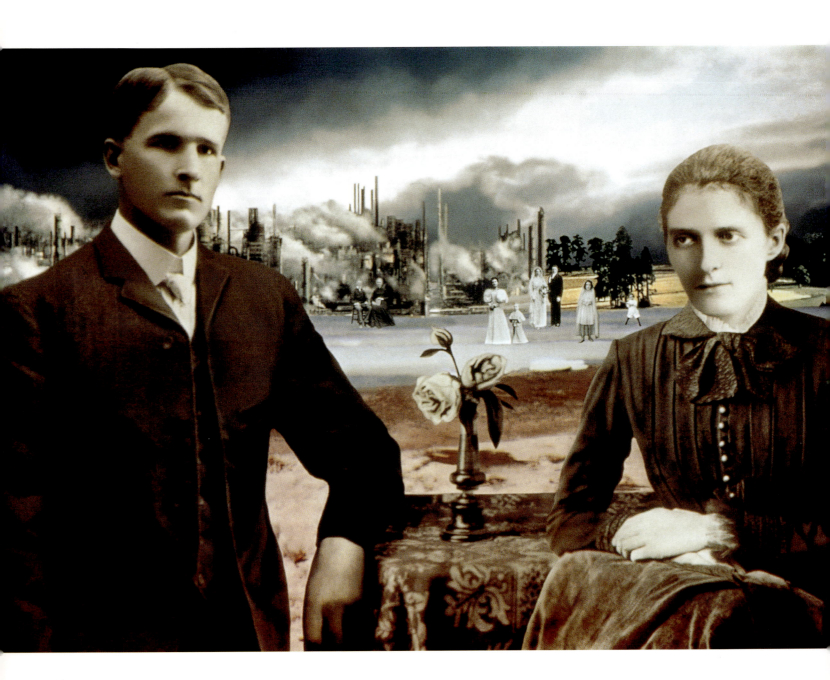

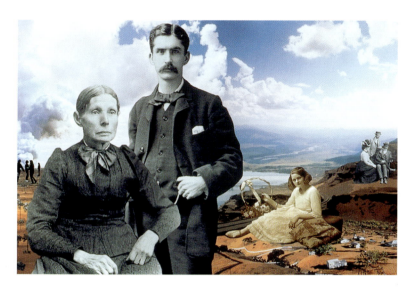

Project *In the Way of Tradition*
Rendering size 30" x 50" (76 cm x 127 cm)

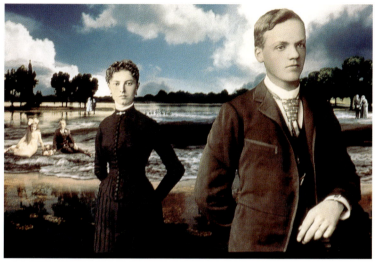

Project *In View of the Heart*
Rendering size 30" x 50" (76 cm x 127 cm)

Martina Lopez

In Lopez's work the visages of forgotten families mingle in unfamiliar landscapes. Their faces seem to decry their fate—being removed from the decisive moment when they were fixed on paper and re-posed with a technology that didn't exist until one hundred years after their death. Having moved from black-and-white to color photography, Lopez found this "freed" her to "actually tear up my prints." Lopez collects her picture elements from secondhand stores and family albums. Working from a rough sketch, she creates her pictures digitally and outputs to a 4" x 5" (10 cm x 13 cm) transparency for printing on photographic paper. She sees the landscape as a metaphor: "the horizon suggests an endless time, . . . the trees demarcate its quality," and reassembled figures, "with their gestures and expressions, reflect my personal dreams and contemplations."

Project *Drive-in Theater: Godzilla and White Trailerhouse* (one of a series)
Rendering size 26" x 40" (66 cm x 102 cm)

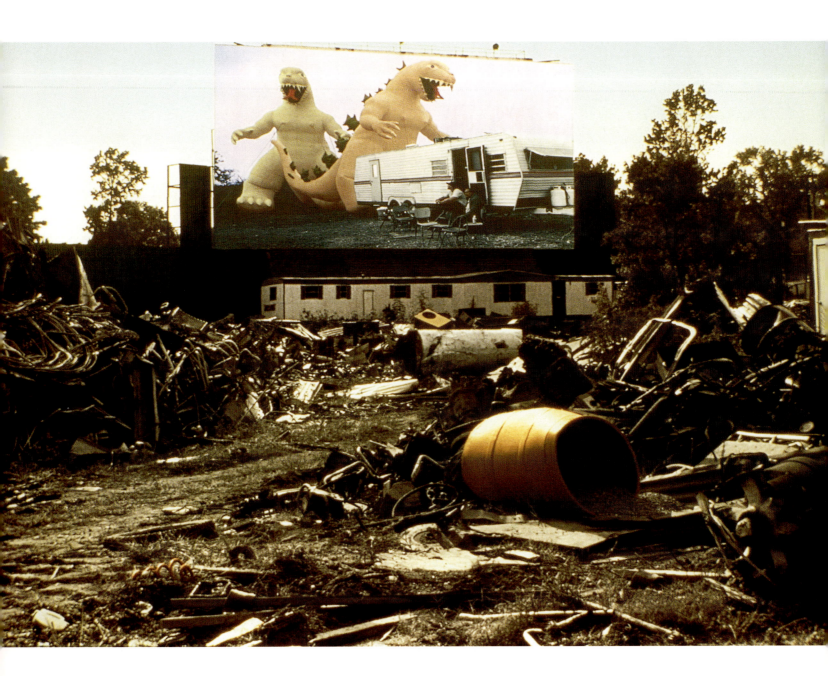

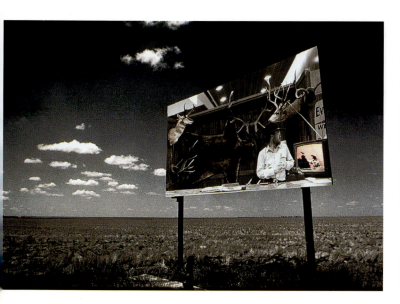

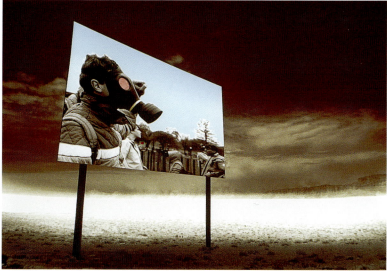

Project *Billboard: Cowboys* (one of a series)
Rendering size 26" x 40" (66 cm x 102 cm)

Project *Billboard: Gas Mask* (one of a series)
Rendering size 26" x 40" (66 cm x 102 cm)

Osamu James Nakagawa

With billboard images that belie their landscape hosts, Nakagawa proclaims what was, what can be, and what will be in his environmental views of consequence. For Nakagawa, photomontage is "a means to a communicative end." He combines multiple pictures to "create a visual space that begins to question the notion of photography's ability to depict reality." Beginning with black-and-white photographs, the work is composed and altered digitally and output to 4" x 5" (10 cm x 13 cm) negatives for printing on photographic paper. The resulting photomontages have all the "qualities of a chemical image, including the evidence of grain." This series uses the "idea of a frame within a frame," juxtaposing the "nostalgic mythology of the drive-in theater" with "explicitly public and political messages."

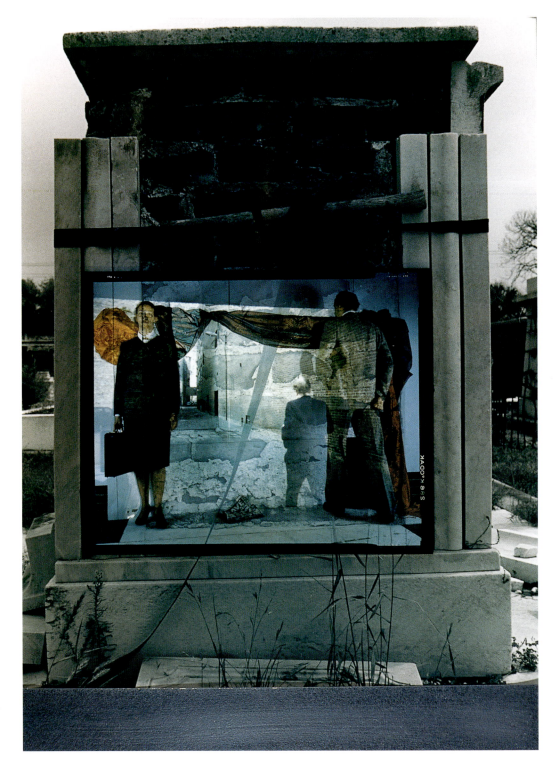

Project *Business as Usual in a Time of Recession* (one of a series)
Rendering size 8" x 10"
(20 cm x 25 cm)

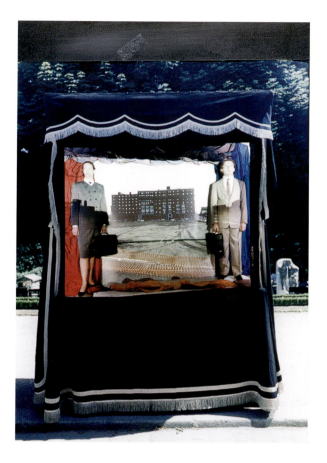

Project *Business as Usual in a Time of Recession* (one of a series)
Rendering size 8" x 10" (20 cm x 25 cm)

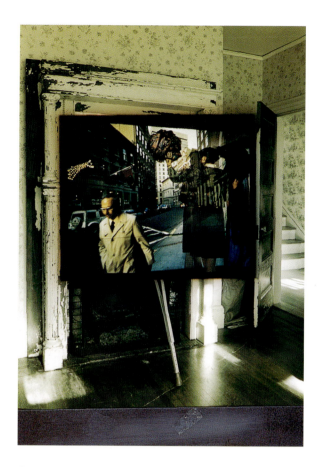

Project *Business as Usual in a Time of Recession* (one of a series)
Rendering size 8" x 10" (20 cm x 25 cm)

Bart Parker

In Parker's work the business world becomes a stage; isolated and debunked, it speaks of the cost in flesh. It's *rush, don't think, don't look back*—because in business only tomorrow counts. With a heart and soul steeped in his poet's past—Parker sees a correlation between the "linkages and consequences" in photomontage and poetry. Photomontage offered a way to solve the "approach/avoidance" issues he had with the "traditional single-minded, previsualized, sliver-of-time" photography. Parker begins by making "long exposures of numerous exposures" using people, sets, and rear-screen projection. Negatives are contact-printed, and picture elements are added with the use of opaque masks. The "money-oriented," "secretive and violent" business world is looked at with "anger and laughter" in this work.

Project *Action Attraction*
Rendering size 21" x 27"
(53 cm x 69 cm)

Olivia Parker

On close inspection of Parker's work, viewers are both summoned and befuddled. By holding their secrets very close, these images don't reveal themselves easily; are they witticisms or deep messages? After twenty years of working in photography, Parker "waited eagerly for digital imaging to evolve into a viable tool." Photomontage allows her to move off the map again in search of new adventures. Having always been interested in fiction, Parker scans prints, transparencies, and diagrams into a computer—"enabling me to make photographs of fiction." In this work, which alludes to toys and games, the viewer finds that Parker's "games have an obvious relationship to the structure of real games, but usually something has gone wrong: players are using different rules; the instructions are missing."

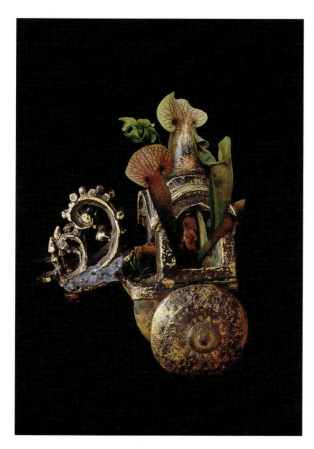

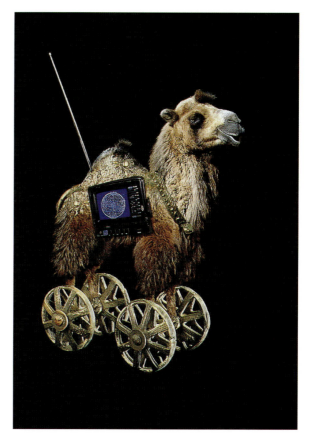

Project *Herbivore-Carnivore*
Rendering size 20" x 24" (51 cm x 61 cm)

Project *Mr. Johnston's Pull Toy*
Rendering size 16" x 20" (41 cm x 51 cm)

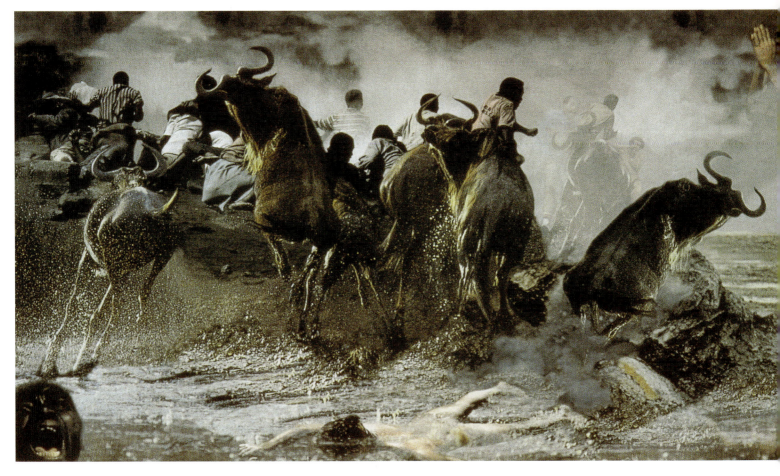

Project *Panic*
Rendering size 44" x 32" (112 cm x 81 cm)

Richard Rosenblum

The news takes on historical proportions in Rosenblum's fictional dramas. The viewer is reminded of the powerful—albeit generic quality that images of conflict and war often possess. Originally trained as a sculptor, Rosenblum was led by logistical issues to digital imaging. He discovered photomontage, "was instantly hooked, and have never really returned to sculpture since." Though working digitally with flat pictures, Rosenblum relates the process to "the way I sculpted—looking for an image by cutting and pasting." He adds, "In general the whole process is about imagination rather than technique." Rosenblum is an example of an artist concerned less with labels and materials than with a tool allowing him "more control over the visual world than anything I'd experienced before."

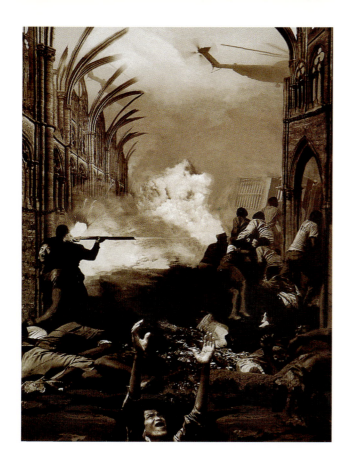

Project *Sarajevo*
Rendering size 44" x 32" (112 cm x 81 cm)

Project *California Dreaming*
Rendering size 44" x 32"
(112 cm x 81 cm)

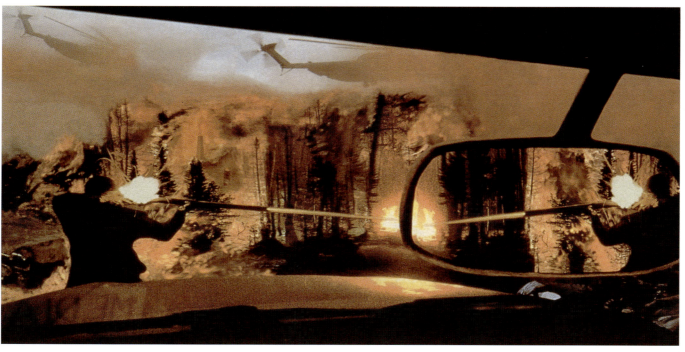

Vaughn Elaine Sills

Years slip by and loved ones with them. Sills places pages from her own family story in simple, elegant layers. Arranged with love, care, and artistry, family photographs become inextricably linked, like the people they represent. Photomontage gives Sills the "perfect medium" for taking the "treasures" of her childhood—words and pictures—and re-using them "like words and lines in a poem." These assemblages are "pictures of my memory; they are the images of my reality." With deceptively simple aplomb, Sills rephotographs her work on a copy stand, then makes a print that she tones selectively. "I began wanting to remember my childhood" relationships with her mother and grandmother—and with this work she says, "I find things that I did not know."

Project *Resembling Myself*
Rendering size 16" x 20" (41 cm x 51 cm)

Project *Thirty-four*
Rendering size 16" x 20" (41 cm x 51 cm)

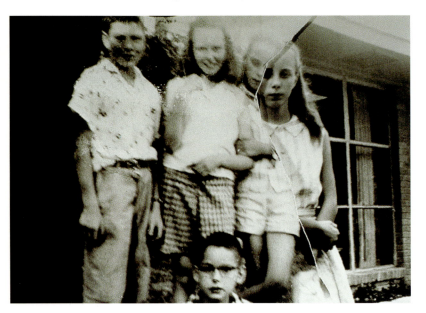

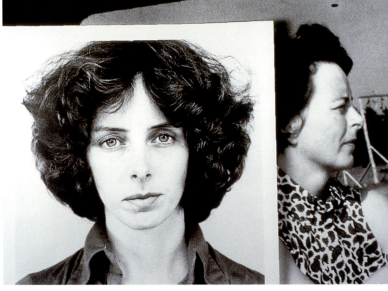

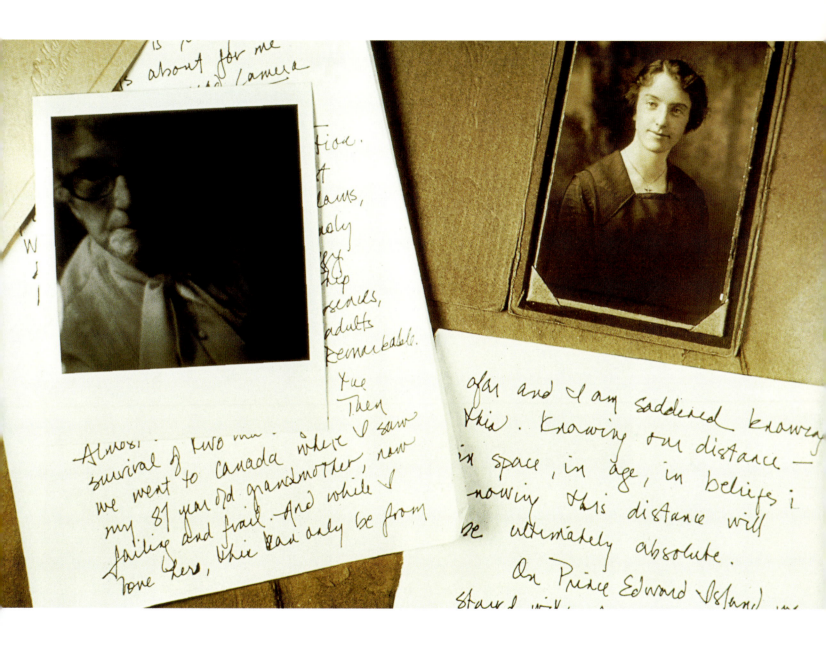

Project *Knowing Our Distance*
Rendering size 16" x 20" (41 cm x 51 cm)

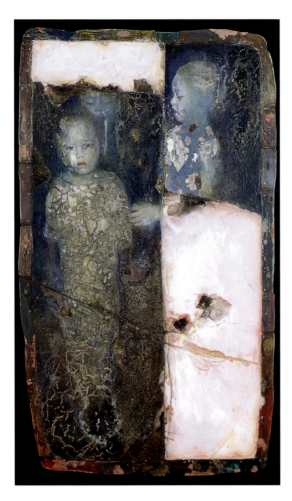

Project *Three Girls*
Rendering size 35" x 21"
(89 cm x 53 cm)

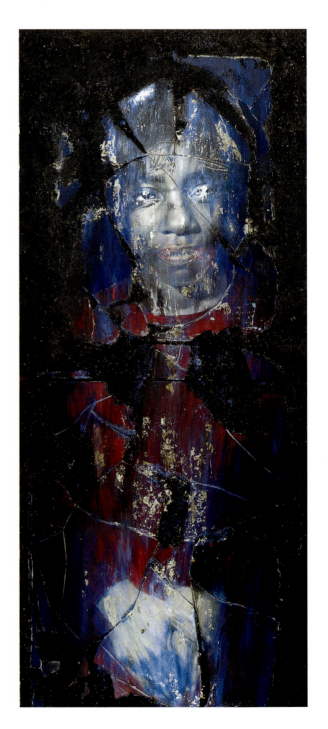

Esther Solondz

Solondz's pictures reveal their soul through color, expression, and gesture. They are the rare portraits that project their subjects' spirits, beckoning viewers to pause and appreciate the opportunity before them. Solondz has "painted over, scraped off, sanded, cut up, dug into, and torn off photographs"—and still found that "the original photograph always persisted." As much a painter as a photographer, she exemplifies how broadly people can work under the label of photomontage. Using multiple picture elements, Solondz glues them to wood and applies such diverse materials as plaster, paint, powdered pigments, beeswax, gold leaf, and even "sterilized" dirt. Believing that we are linked through genes to people long forgotten, Solondz examines how "these ancient things, sacred things, elemental things endure."

Project *Untitled* **Rendering size** 25" x 10" (64 cm x 25 cm)

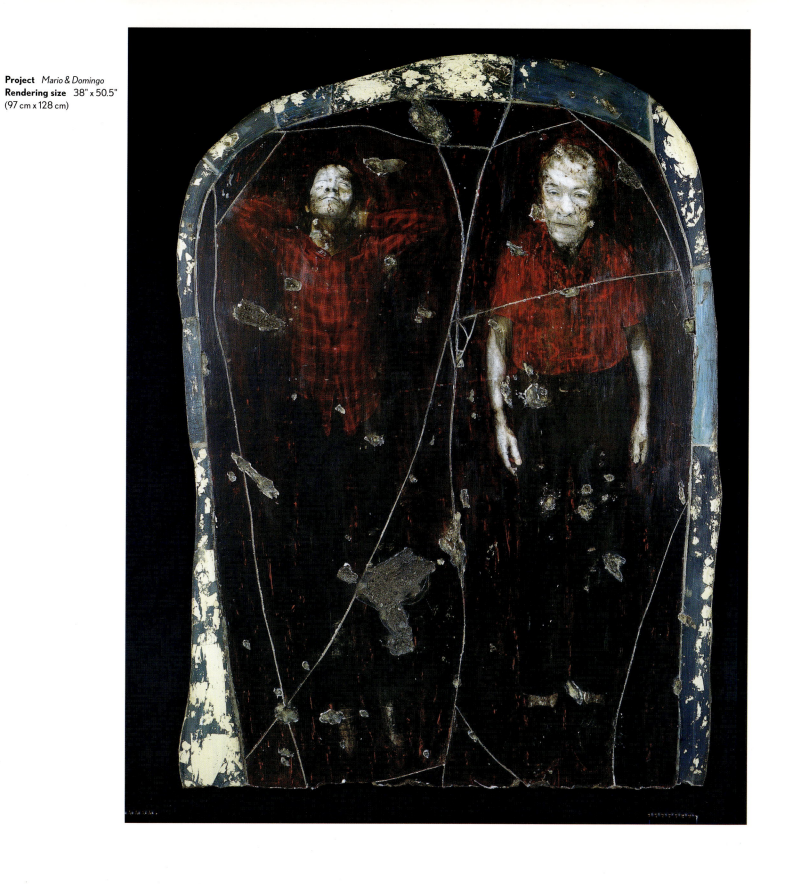

Project *Mario & Domingo*
Rendering size 38" x 50.5"
(97 cm x 128 cm)

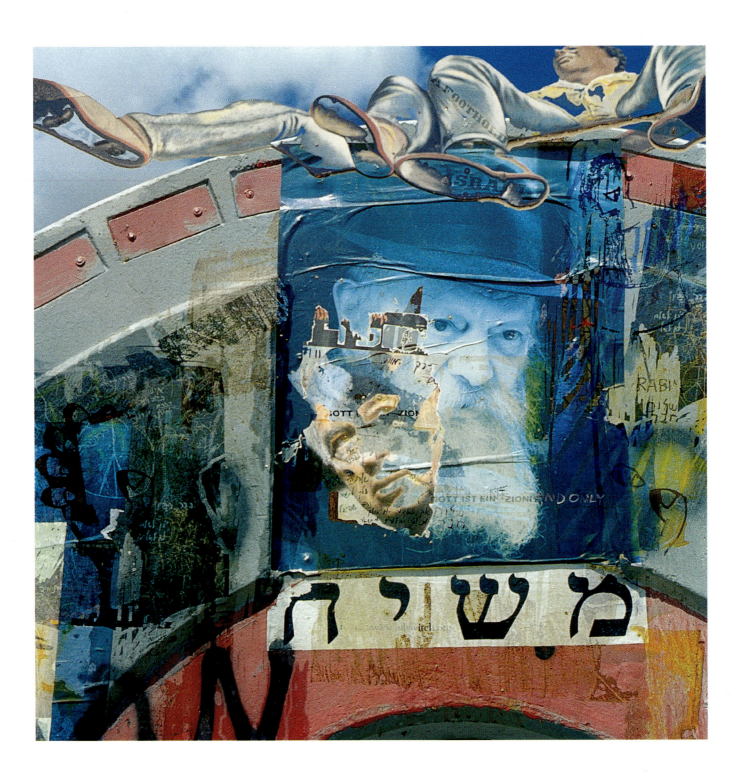

Project *Messiah—WWW Lubavitch Org.*
Rendering size 30" x 30" (76 cm x 76 cm)

Leslie Starobin

Telling her tales in prayer-like, hushed, and private tones, Starobin navigates the viewer through an intricate history. Color and shape peel away, unveiling distant pictures and random thoughts. Photomontage is a way for Starobin to "echo the sounds of urban Israel—a loud babble of tongues distinct in visual type." Having found that making photomontages mechanically was "less than desirable," she switched to digital imaging. Starobin says, "The computer process allows me to seamlessly fuse together as many of these varying elements as I need to create each visual image." Using family pictures, text representing five languages, and urban wall art, she assembles amalgams with layers that are in "fierce competition for the viewer's attention," like the graffiti they're based on.

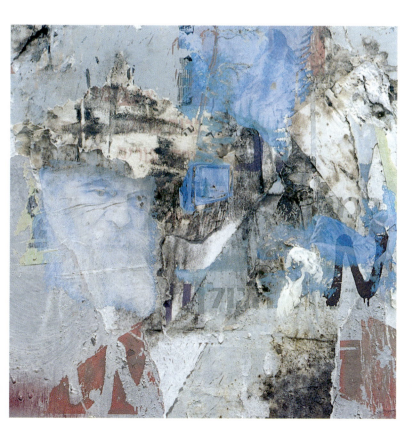

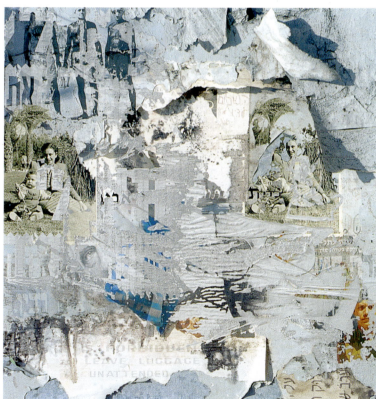

Project *Driving North to Golan*
Rendering size 30" x 30" (76 cm x 76 cm)

Project *Blue on Rembrandt Street*
Rendering size 30" x 30" (76 cm x 76 cm)

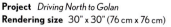

Jane Tuckerman

Tuckerman's work stirs deep feelings of spiritual and physical suffering. Her obvious cut-and-tear approach complements the raw emotion being revealed, transporting the viewer into dark areas of the human condition. Tuckerman's interest in photomontage began when, as a child, she watched her father paste clippings into a scrapbook. She now finds interest in the "simultaneous realities" resulting from the combination of images. Working mechanically, she tones and dyes the pictures, "further deconstructing the infrared images with haphazardly applied bleach." Color is added with pastels, and figures are glued on, "further tormented with streaks of charcoal and strands of chalk." This work, which reflects on mortality, myth, and rite, began after Tuckerman was invited to document death rituals in Benaras, India.

Project *The Displaced* (one of a series)
Rendering size 20" x 24" (51 cm x 61 cm)

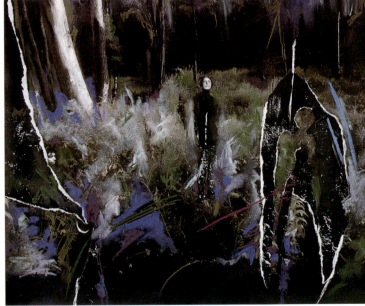

Project *The Displaced* (one of a series)
Rendering size 20" x 24" (51 cm x 61 cm)

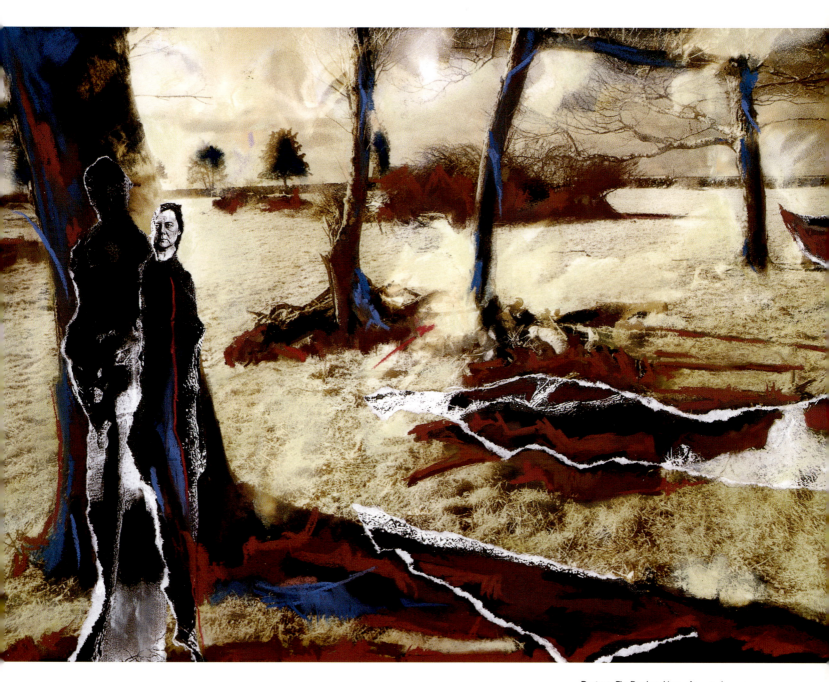

Project *The Displaced* (one of a series)
Rendering size 20" x 24" (51 cm x 61 cm)

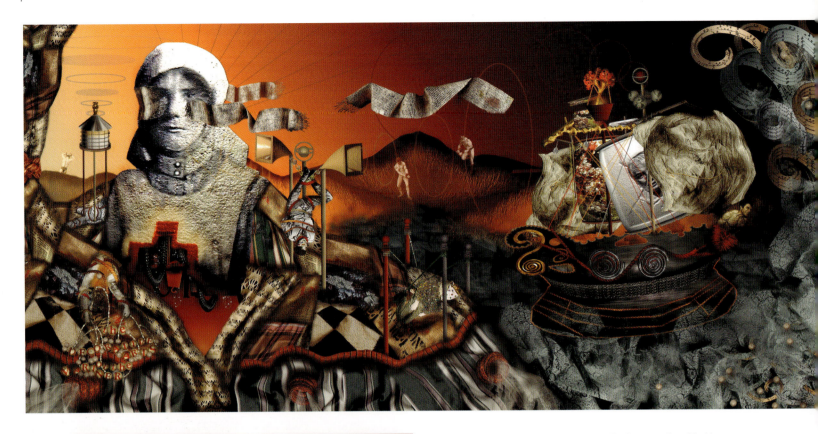

Project *The Decorative Arts of the Mariner*
Rendering size 35" x 24" (89 cm x 61 cm)

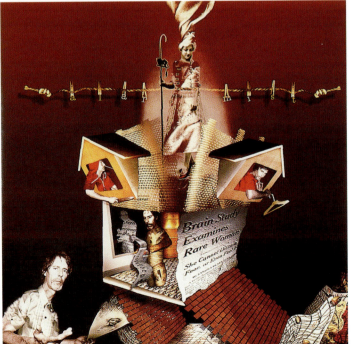

Project *Alarmist*
Rendering size 35" x 35" (89 cm x 89 cm)

Anna Ullrich

Ullrich is one of a new breed of young artists raised in the milieu of the digital studio. Her work reflects not just skillfulness and comfort with the technology, but a new aesthetic frontier that is just coming into view. By working in photomontage Ullrich is able to "create dialogues between images"—what she calls "a surreal brew that transcends the reality of the individual elements." Scanned images and objects from a three-dimensional rendering program are imported into Photoshop for manipulation, and finally assembled in RIO, a DOS-based image editing and compositing application. This series explores "how popular culture informs the male experience;" Ullrich calls it a "self-conscious reflection on the nature of masculinity and an attempt to understand how women sexualize men."

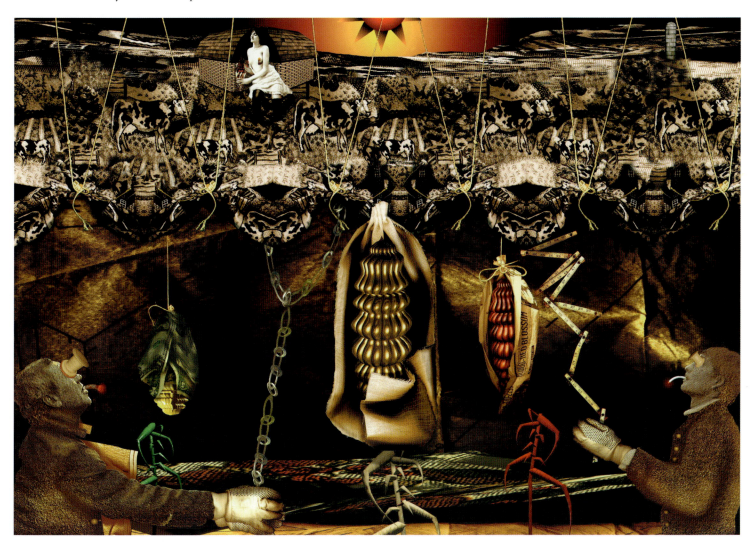

Project *Husks*
Rendering size 35" x 24" (89 cm x 61 cm)

137

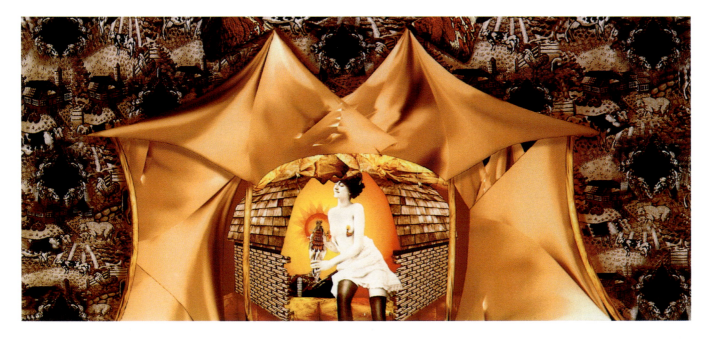

Anna Ullrich
Project *Spread*
Rendering size 35" x 18" (90 cm x 46 cm)

Artworks marked with an asterisk appear in stages of their composition as illustrations of the techniques described, and are by author Stephen Golding.

Index

Directory

Audry Bernstein Photography
12 Southlawn Avenue
Dobbs Ferry, NY 10522

Maryjean Viano Crowe
Fine Arts Department
Stonehill College
North Easton, MA 02357

Stephen Golding
100 Harvard Street
Newtonville, MA 02160
phone/fax 617-969-7213
sgolding@aol.com

Robert Hirsch
Executive Director
CEPA Gallery
700 Main Street, 4th Floor
Buffalo, NY 14202

Will Larson
120 Hapwood Road
Collegeville, PA 19426
phone 610-489-3317
wlarson@mica.edu

Martina Lopez
1020 North Western Ave.
Chicago, IL 60622

Osamu James Nakagawa
USA:
9722 Mariposa
Houston, TX 77025
fax 713-661-9639
onakagawa@aol.com
Representation:
McMurtrey Gallery
3508 Lake Street
Houston, TX 77098
phone 713-523-8238
Tokyo:
c/o Takeshi Nakagawa
111 Ninomiya Machi, Ninomiya
Nakagun, Kanagawa, Japan
259-01

Bart Parker
43 Duncan Avenue
Providence, RI 02906-1814
phone 401-273-4479
parb@uriacc.uri.edu
Representation:
Visual Studies Workshop Gallery
31 Prince Street
Rochester, NY 14607

Olivia Parker
Rober Klein Gallery
38 Newbury Street
Boston, MA 02116
phone 617-267-7997
fax 617-267-5567

Richard S. Rosenblum
63 Lake Avenue
Newton, MA 02159
phone 617-332-4052
fax 617-969-5195
Representation:
Howard Yezerski Gallery
Boston, MA
Nohra Haime Gallery
New York, NY

Vaughn Sills
Simmons College
Department of Art and Music
300 The Fenway
Boston, MA 02115
vsills@vmsvax.simmons.edu

Esther Solondz
14 Catalpa Road
Providence, RI 02906
phone 401-521-0861

Leslie Starobin
Associate Professor-Communication
Arts Department
100 State Street
Framingham State College
Framingham, MA 01701-9101
phone 617-444-8641
fax 617-444-0792

Jane Tuckerman
Box 3103
Westport, MA 02790
The Art Institute of Boston
700 Beacon Street
Boston, MA 02215-2598
phone 617-262-1223

Anna Ullrich
http://www.netdreams.com/registry/
list.html

About the Author

Stephen Golding has been creating photographic art for more than twenty-five years. His works have been displayed at the DeCordova Museum; the Krannert Art Museum; and Harvard and Princeton Universities. His works have been published by MIT, *Art New England* and *Wired*, and uploaded to the World Wide Web site @art gallery. Golding also has been awarded a regional fellowship from National Endowment for the Arts through the New England Foundation for the Arts.